FRANCIS BACON

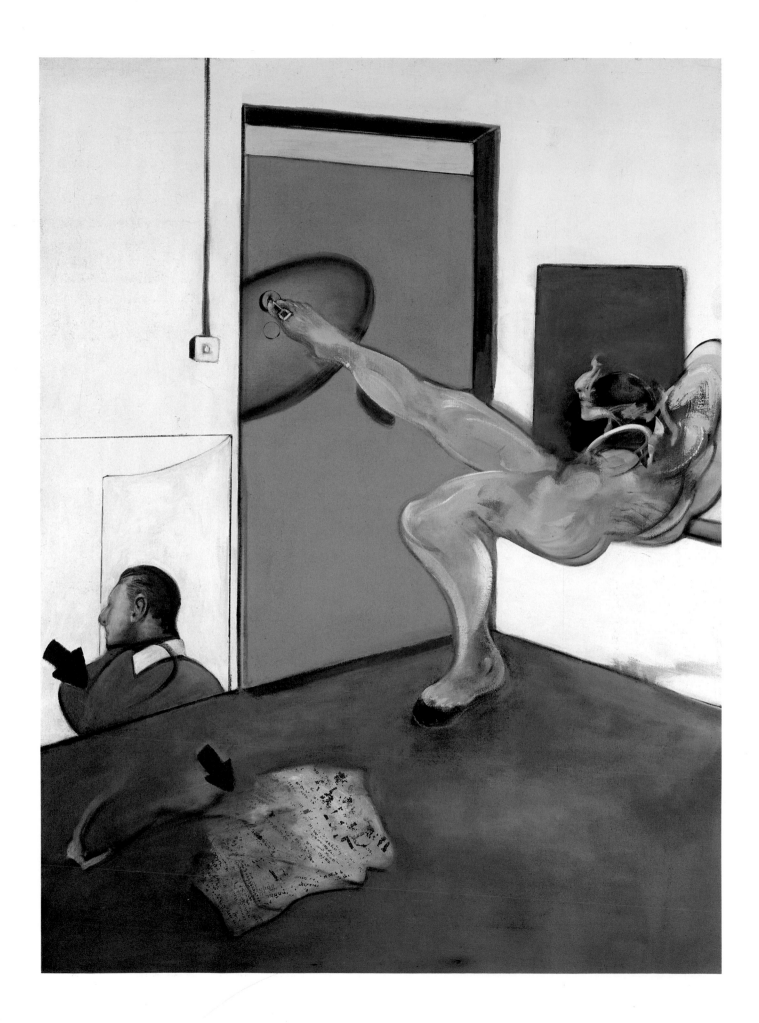

MODERN MASTERS

FRANCIS BACON

HUGH DAVIES AND SALLY YARD

Abbeville Press · Publishers
New York · London · Paris

Francis Bacon is volume nine in the Modern Masters series.

For Alex

ACKNOWLEDGMENTS: Without the insight, encouragement, and help of Valerie Beston of Marlborough Fine Art Ltd., London, this book would not have come about. We greatly appreciate the clarity of thought and expression of Nancy Grubb, who has been an empathetic editor. Sam Hunter was vital at the inception of this study, and we have benefited from the perceptions and knowledge of our colleagues David Sylvester and Mark Roskill.

We are above all indebted to Francis Bacon for agreeing to the numerous interviews over the past fourteen years that have enriched this book and for reviewing successive drafts of the manuscript.

FRONT COVER: *Self-Portrait* (major portion), 1969. See plate 1.
BACK COVER: *Figure in Movement,* 1985. See plate 102.
ENDPAPERS: Francis Bacon, 1984. Photographs by John Edwards.
FRONTISPIECE: *Painting,* 1978. Oil on canvas, 78 x 58 in. Private collection, Monaco.

Series design by Howard Morris
Editor: Nancy Grubb
Designer: Florence Mayers
Picture Editor: Laura Yudow
Production Manager: Dana Cole
Chronology, Exhibitions, Public Collections, and Selected Bibliography compiled by Daniel Starr

Marginal numbers in the text refer to works illustrated in this volume.

Library of Congress Cataloging-in-Publication Data

Davies, Hugh Marlais, 1948–.
 Francis Bacon.
 (Modern master series, ISSN 0738-0429; v. 9)
 Bibliography: p.
 Includes index.
 1. Bacon, Francis, 1909–1992. 2. Painters.—England—Biography. I. Yard, Sally.
II. Title. III. Title: Bacon IV. Series.
ND497.B16D38 1986 759.2 85-6044
ISBN 0-89659-447-5
ISBN 1-55859-245-8 (pbk.)

First edition, 15 14 13 12 11 10 9 8 7

Contents

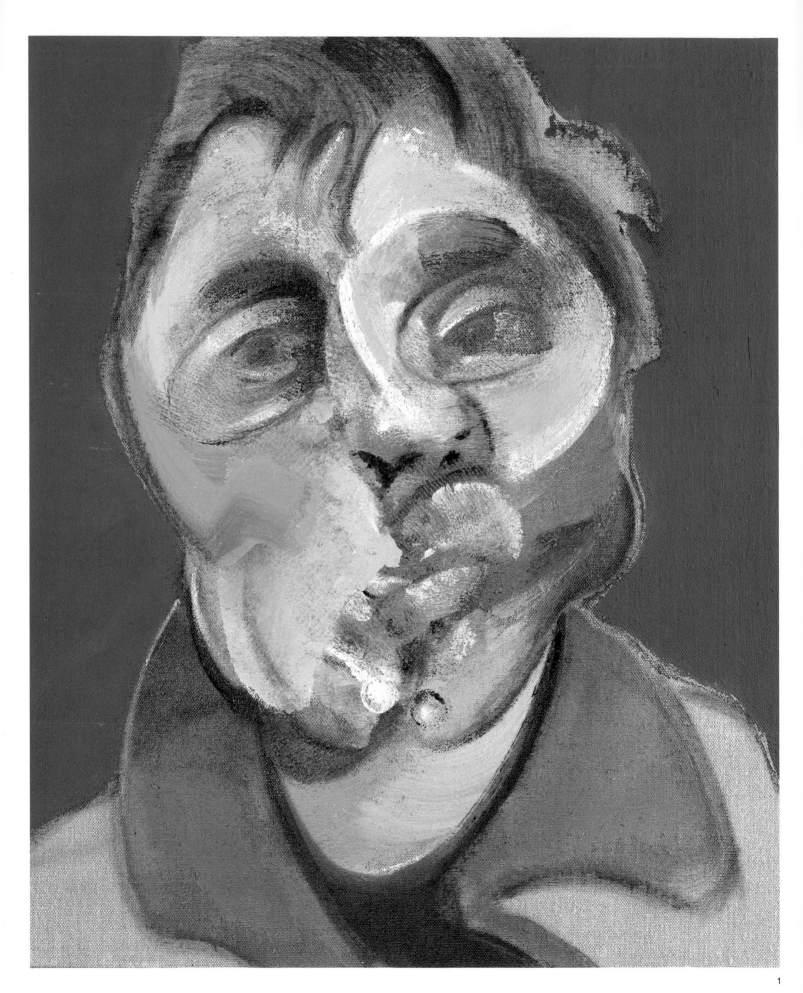

Introduction

Francis Bacon has steadfastly focused on figurative subject matter throughout his career. Dissatisfied with abstraction's lack of human content, he has distorted the inhabitants of his painterly world in order to "unlock the valves of feeling and therefore return the onlooker to life more violently."[1] The murky settings that engulfed his figures for more than a decade after World War II were banished by the brightly illuminated clarity of subsequent work, but the contours that described the figures remained tortuous as the blurring of earlier images gave way to the smearing of paint in later ones: "The mystery lies in the irrationality by which you make appearance—if it is not irrational, you make illustration."[2]

While the vigor of Bacon's paintings parallels that of the Abstract Expressionism of the late 1940s and early '50s, his work has nonetheless remained firmly based in the figuration that also sustained the art of Henry Moore and Graham Sutherland. But Moore's benign family groups and the traditional religious imagery of Sutherland's Crucifixions of the immediate postwar period are remote from the raging figures who dominate Bacon's painterly world of those years. And how strident his paintings must have seemed during the 1950s and '60s next to the spare abstractions of Ben Nicholson, the veils of Morris Louis, the geometric permutations of Frank Stella. At a moment when artists such as Robert Smithson and Michael Heizer in America and Richard Long in Britain were moving out-of-doors to create vast environmental works known to most viewers only in photographic documentation, Bacon's work moved inward, probing the private realms of the psyche. In the vehemence of his attack on the human figure Bacon's work aligns with that of the French artist Jean Dubuffet, although Dubuffet's crude surfaces and primitively hewn forms are far from the sumptuous facture and mesmerizing distortions of Bacon.

Bacon has in fact stayed resolutely aloof from the successive regroupings of recent art, unmoved by the abstraction that became internationally dominant by the close of World War II. While his paintings have consistently referred to contemporary life, he has also consciously rivaled the old masters. Pointing to the gestural,

1. *Self-Portrait*, 1969
Oil on canvas, 14 x 12 in.
Private collection

nonrational marks that "coagulate" in Rembrandt's work to convey the "mystery of fact," Bacon observes:

And abstract expressionism has all been done in Rembrandt's marks. But in Rembrandt it has been done with the added thing that it was an attempt to record a fact and to me therefore must be much more exciting and much more profound. One of the reasons why I don't like abstract painting, or why it doesn't interest me, is that I think painting is a duality, and that abstract painting is an entirely aesthetic thing. . . . There's never any tension in it.[3]

For his subject matter, Bacon has turned to a world in which he sees no inherent nobility or grand design. "I think of life as meaningless; but we give it meaning during our own existence. We create certain attitudes which give it a meaning while we exist, though they in themselves are meaningless, really." Bacon's works are records of his own subjectivity, inflected with what he calls "exhilarated despair."[4] Yet throughout Bacon's oeuvre there has also been a recollection of myth. He has returned several times to the themes of the Crucifixion and the fate of Prometheus, and he has repeatedly invoked the Furies of Aeschylus's *Oresteia*. But his is a modern outlook, formed at a time when the ancient dramas of Oedipus and Orestes have assumed fresh pertinence in light of Freudian theories. The Furies have haunted Bacon's work since their appearance in *Three Studies for Figures at the Base of a Crucifixion* (1944); they reappeared thirty years later in *Seated Figure*, calling to mind the Eumenides who pursue Harry to Wishwood in *The Family Reunion* (1939), Bacon's favorite T. S. Eliot play.[5] Harry echoes the cry of Orestes, which had served as an epigraph for Eliot's earlier "Sweeney Agonistes": "You don't see them, you don't—but *I* see them: they are hunting me down, I must move on." The themes of pursuit and of the predatory observer became central to Bacon's work from the 1960s onward, as figures poised at doorways look back uneasily and voyeurs intrude into the bedrooms of embracing couples.

In seeking to trap the likeness of life Bacon has been receptive to the promptings of chance: "I think that accident, which I would call luck, is one of the most important and fertile aspects of it. . . ." But the artist's mediation is crucial. "It's really a continuous question of the fight between accident and criticism. Because what I call accident may give you some mark that seems to be more real, truer to the image than another one, but it's only your critical sense that can select it."[6] Bacon has cultivated the potent collisions of imagery that he had encountered early on in Surrealism and, perhaps more important, in the tragedies of Aeschylus. He continues to be fascinated by William Bedell Stanford's book *Aeschylus in His Style*, with its vivid translations of such synaesthetic metaphors as "the reek of human blood smiles out at me."[7]

If Bacon has remained committed to exploring the dark corners of human existence, he has never been interested in straight realism and has stayed far from the Superrealist and Photorealist tendencies of the 1960s and '70s. Dismissing simple representation as essentially illustrational, Bacon cites van Gogh's declaration that

<div style="text-align:right">8
98</div>

2

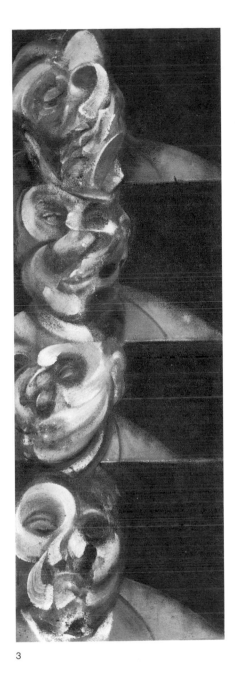

3

"my great longing is to learn to make those very incorrectnesses, those deviations, remodelings, changes in reality, so that they may become, yes, lies if you like—but truer than the literal truth."[8] Along with a very few other artists—among them Frank Auerbach in England, Leon Golub in America, and Karel Appel in Holland—Bacon has amplified the expressive resources of figuration. With the resurgence of figurative imagery and the international emergence of Neo-Expressionism during the past decade, the pivotal importance of his work has become emphatically clear. Although Bacon taught only briefly, at the Royal College of Art in London in 1950, his influence can be discerned in the work of painters ranging from Richard Hamilton and David Hockney to R. B. Kitaj and Malcolm Morley, and his art has commanded the attention of such contemporaries as Willem de Kooning. The fragmented figures of Hockney's recent work, pieced together from multiple photographs, mirror strikingly the dislocations of Bacon's work. Bacon's importance has also extended to such filmmakers as Bernardo Bertolucci, which is especially appropriate since photography and film have proved so inspirational to the artist: "I think one's sense of appearance is assaulted all the time by photography and by the film. . . . I've always been haunted by them. . . . I think it's the slight remove from fact, which returns me onto the fact more violently."[9] The spaces and action of *Last Tango in Paris* owe much to Bacon's art, an allusion acknowledged by Bertolucci in his use of two of Bacon's paintings during the opening credits.

That Bacon's work has been a force unto itself for nearly half a century has not deterred museums and galleries from lavishing attention on him. Major retrospectives assembled by the Tate Gallery in 1962 and the Guggenheim Museum in 1963 confirmed his position in Europe and America. Important exhibitions of his paintings in Paris, Düsseldorf, and New York during the 1970s were timely, as such artists as Georg Baselitz, Anselm Kiefer, and Jörg Immendorff in Germany; Sandro Chia and Francesco Clemente in Italy; and Eric Fischl, Susan Rothenberg, and David Salle in America were challenging the twenty-year hegemony of nonobjective art with bold figurative images. In 1985, after nearly a quarter of a century, the Tate Gallery organized a second major retrospective.

From a distance of forty years, Bacon's clamorous appearance on the London art scene in the 1940s seems a crucial moment in modern art. As artists in England sought to restore the wholeness of humanity and painters in America pressed toward increasing abstraction, Bacon aggressively confronted the blunt realities of existence. Nearly two decades would elapse before the figure would regain a central position in Western art and before such dissimilar German artists as Immendorff and Joseph Beuys would take as their subject the human evil revealed during the first half of our century. By then the magisterial thugs of Bacon's earlier paintings had been supplanted by the friends who haunt the more recent work. Tackling the unruly imagery of life, Bacon has been guided by mentors past and present. Alerted by Freud and the Surrealists to the startling insights of the subconscious and impressed by the blunt potency of news photographs, he has been no less dazzled by the formal rhythms of the art of earlier centuries.

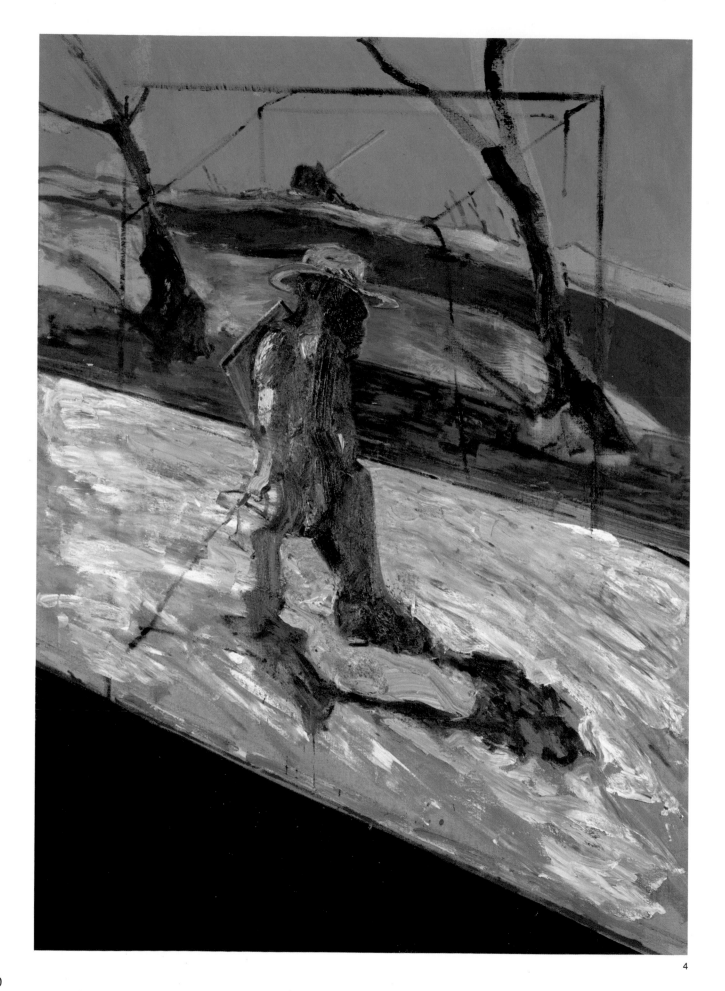

1 Images after Art

Claiming that "I had no upbringing at all, and I used simply to work at my father's racing stable near Dublin," Bacon has portrayed his early life as unstructured and rural. His recollection that "I read almost nothing as a child—as for pictures, I was hardly aware that they existed,"[10] reflects the informality of his education but scarcely suggests the rich if unconventional character of his formative years.

Bacon was born in 1909 into an English family living in Dublin. During Francis's earliest years, his father, Edward Anthony Mortimer Bacon, was a breeder and trainer of horses in Ireland. When Francis was five years old, the elder Bacon joined the War Office in London, and from this time on the family made its home alternately in England and Ireland. Of the relatives with whom the Bacon children spent a good deal of time, Bacon's maternal grandmother was perhaps the most memorable. The grace of her country house, Farmleigh, was epitomized by the semicircular bay-windowed spaces that captured the imagination of her young grandson and that he would recast decades later in scenes of violence and disarray.[11]

The mood of well-being at Farmleigh was disturbed by civil war.

I was in Ireland through the Sinn Fein . . . very curious effect, especially since my parents were the enemy. My father warned us that at any time, not that we would be shot, but at night someone might break in or whatever. . . . At that time my grandmother was married to the head of police in Kildare and in their house all the windows were sandbagged. I lived with my grandmother a lot. I grew up in an atmosphere of threat for a long time. It was strange to come to half-camouflaged ditches dug in the road and to drive into a field to get around them.[12]

The jarring imposition of these defensive wartime measures on a carefully ordered domestic life pointed ahead to the disjunction between cultivated appearance and raw reality that is central to Bacon's art. Just as the hospitable openness of life in Ireland was undermined by the possibility of ambush at any corner so, in Bacon's art, does the public composure of pope, politician, and businessman disintegrate in the privacy of a closed room.

4. *Study for Portrait of Van Gogh II*, 1957
Oil on canvas, 78 x 56 in.
Edwin Janss, Thousand Oaks, California

His family's frequent moves made Bacon's schooling erratic: he was tutored for a brief time by the local parish priest in Ireland and attended Dean Close School in Cheltenham before running away. At age sixteen Bacon set off for London and by 1927 had made his way to Berlin and then Paris, where he lived for about a year and a half. The decadence of Berlin during these years, its streets lined with erotic sideshows promoted by street hawkers, must have contrasted startlingly with the atmosphere of the Catholic country where Bacon had spent much of his youth. Bacon, who had embarked upon a career as a designer of interiors and of furniture, was not particularly interested in the museums and galleries of Paris, although one exhibition, of work by Picasso at the Rosenberg Gallery, proved crucial, providing the impetus for Bacon to consider becoming a painter.[13]

5 The sleek lines of the furniture that Bacon designed and the pristine spareness of his studio can be seen in "The 1930 Look in British Decoration," an article published in *The Studio*. Like his furniture, the few paintings that survive from this period are hard-edged and crisply delineated. The elegance of Bacon's interior design and paintings gave way in the early 1930s to the vigorous distortions of a group of figurative works. Among these were three Crucifixions

8 of 1933, which culminated eleven years later in *Three Studies for Figures at the Base of a Crucifixion*, now in the Tate Gallery, London. In subject, the Crucifixions heralded Bacon's tendency to confront the grimmest realities of human existence. Formally, these and other works of the decade attest to Picasso's influence.

Bacon was encouraged in painting the Crucifixions by his friend Eric Hall, who in 1937 included three of Bacon's images in an exhibition at Agnew's of works by leading young British painters. Along with Graham Sutherland, the roster of ten artists included Roy de Maistre, whom Bacon had known since the start of the decade. A painter of Christian subjects, de Maistre was a convert to Catholicism who advised, "In one's life one ought to be gentle and forbearing, but in one's art one should conduct oneself quite differently. It's often necessary, for instance, to give the spectator an ugly left uppercut."[14]

While Bacon's 1933 paintings suggest an artist concentrating more on formal than on expressive concerns, in the 1944 Tate triptych the human figures have become strained and attenuated, and the Crucifixion has apparently come to symbolize for Bacon man's inhumanity to man. Thirty years later he disclaimed any interest in the subject's meaning, remarking, "I'm fascinated by the body raised from the ground, it's more formal and abstract being elevated."[15]

6 *Crucifixion* (1933) foreshadows the schematic articulation of space and the isolation of the figure that have persisted throughout Bacon's work: three lines radiate out from the figure, crudely locating the form in space. This painting was purchased by Sir Michael Sadler, England's leading collector of contemporary art, who subsequently sent Bacon an X ray of his skull on which to base a portrait. Instead, Bacon incorporated this bone structure,

7 painted in sensuously fleshy pinks, next to the taut figure of *Crucifixion with Skull* of 1933.

5

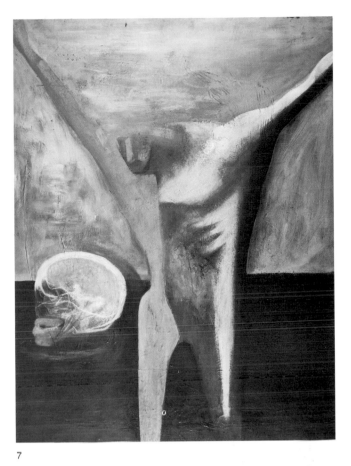

6

7

While Bacon's own participation in exhibitions was sporadic and discouraging during the 1930s, his visits to the exhibitions of others remained inspiring. If his firsthand experience of Picasso's work in 1928 had impelled Bacon to become a painter, an encounter eight years later with Surrealist art was to prove decisive in determining how and what he would paint. The *International Surrealist Exhibition*, organized by Herbert Read, Roland Penrose, and André Breton, was presented in June–July 1936 at New Burlington Galleries in London. This first significant exhibition of Surrealism in Britain left a substantial mark on the young Francis Bacon, whose work had been rejected as "insufficiently surreal" by the organizers of the show.[16]

The solid shadows of Giorgio de Chirico's paintings and the linear structure of Alberto Giacometti's *Palace at 4 a.m.* must have seemed compelling to Bacon. But what must have gripped his imagination most powerfully was the unwaveringly violent subject matter of Max Ernst, Hans Bellmer, Victor Brauner, Salvador Dali, and their cohorts. The Surrealists' commitment to expressing the unconscious and unleashing the id must have influenced Bacon conceptually. The dislocations and distortions of the human figure and the invention of often grotesque biomorphic entities would certainly have inspired him formally. Bacon painted very little in the late 1930s and early '40s and destroyed much of what he did produce; little survives from those years. It was not until 1944 that the Tate triptych established the importance of Surrealism to Bacon's early work.

Late in 1942, after a year's sojourn in a country cottage at Petersfield, Hampshire, Bacon again settled in London. He briefly

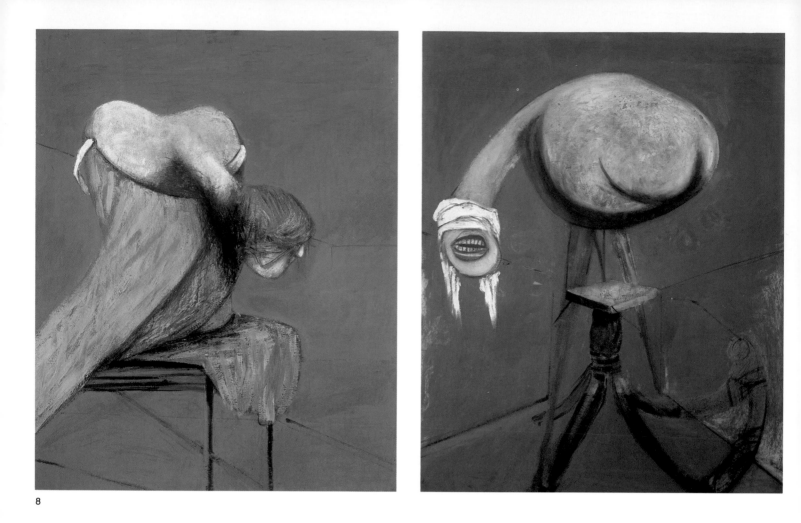

8

worked full-time in Civil Defense (ARP rescue service) until discharged because of his asthma, which had precluded any role in active military service. The dangers of his childhood years in Ireland were echoed in daily life in London during the Blitz, when at any moment normalcy might shatter as terrified civilians rushed for shelter in the Underground. The brutal clarity of wartime life is perhaps mirrored in an outlook noted by David Sylvester in an interview with Bacon: "One thing that's always struck me about you is that, when you're talking about people you know, you tend to analyze how they've behaved or would be likely to behave in an extreme situation, and to judge them in that light."[17]

8 It was while living in a city threatened with periodic death and destruction that Bacon set to work on the first major painting of his career. In the Tate triptych Bacon incorporated the expressive distortions learned from Picasso and the violent subject matter absorbed from the Surrealists in an image that is wholly original in its shrill potency. The snarling teeth of the central figure and the wailing mouth of the one on the right establish with precision central elements of Bacon's imagery. Already apparent in this triptych is the artist's distinctive counterpointing of restless humanoid forms and the stark geometric settings that confine them. The Tate triptych should be viewed as the summation of a dozen years' exploration of the Crucifixion theme rather than as a gut reaction to the devastation of World War II. In its allusions the painting reaches well beyond the horrors of our time to invoke not only the

14

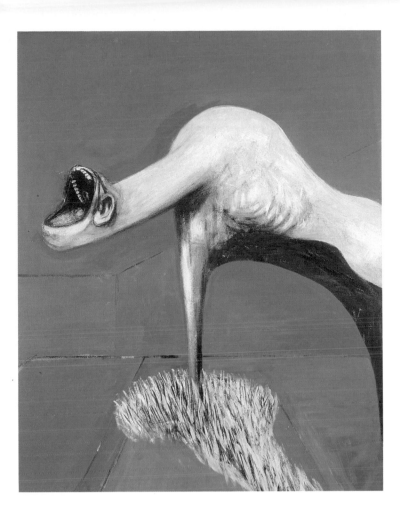

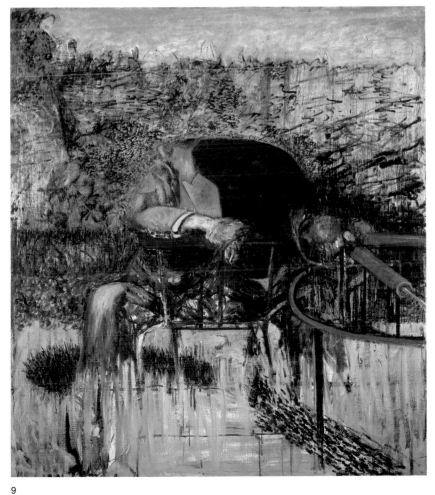

8. *Three Studies for Figures at the Base of a Crucifixion*, 1944
Oil and pastel on hardboard, triptych,
each panel 37 x 29 in.
The Tate Gallery, London;
Gift of Eric Hall

9. *Figure in a Landscape*, 1945
Oil on canvas, 57 x 50½ in.
The Tate Gallery, London

treachery of the Crucifixion but also the vengeful pursuit of the wicked by the Furies,[18] who had been recast as flies two years earlier in Jean-Paul Sartre's play *Les Mouches*.

While the crestfallen female of the left panel is a comprehensible mourner at the cross, her bestial companions defy strictly human interpretation, their barbaric and enraged forms agitating the triptych. The three panels were probably painted from left to right, the central and right sections conceived as variations on the head-lowered pose established in the first frame.[19] The image reflects the influence of art ranging from Grünewald's Isenheim altarpiece of 1510–15 to Picasso's *Guernica* of 1937. While the bandage covering the eyes of the central figure is probably derived from Grünewald's *The Mocking of Christ*, the snarl may well have been triggered by news photos of Nazi harangues.[20] In embracing such irrational confluences and in evoking the vagina (or penis) dentata, the Tate triptych shares much with Surrealism. The organic abstraction seen in these unearthly beings did not recur in Bacon's work until much later, with the appearance of the Furies in such images as *Seated Figure* of 1974. Bacon seems not to have been especially satisfied with the triptych format of the Tate painting; for nearly two decades he elected to work almost exclusively with single images, which at times were conceived in series. Although a portrait of 1953 assumed, as it evolved, a triptych format, it was not until 1962 that Bacon purposely enlisted this structure once again for a large painting, again of the Crucifixion. While Bacon used more readily recognizable imagery following the Tate triptych, the Surrealist underpinnings seen in his biomorphic forms of the 1930s and early '40s have persisted throughout his career in his reliance on accident and the suggestions of the unconscious.

During the next four years Bacon worked slowly, completing on average one painting each year. *Figure in a Landscape* of 1945 was triggered by a pair of utterly disparate photographs. An image of Eric Hall dozing, seated backwards on a chair in Hyde Park, had collided in Bacon's imagination with an agitated news photo of a wartime dictator screaming into a microphone.[21] In the painting the figure's head is drastically displaced, swooping toward the microphones. This pose had preoccupied Bacon earlier in the decade and had crystallized more abstractly in the three panels of the Tate painting. The orator here becomes a brutal figure of gristle and hair, blood and bones. The lush lawns of Hyde Park are rendered parched and hostile, with the grass and shrubbery of the landscape described by short, stablike strokes of black, brown, and dark blue across the unprimed tan canvas. Only the pastel blue band of sky alleviates the charred and ominous mood.

The lowered head with screaming mouth reappears in a crouched figure sheltered by an umbrella in *Figure Study II* of 1945–46. Paralleling the ribs of the umbrella above, the bladelike fronds of a tropical plant radiate beneath the chin of the figure, as though visible evidence of the piercing, vibrating sound. The umbrella-shielded face of this painting was elaborated in *Painting 1946*, completed directly after *Figure Study II*. Though *Painting 1946* began as an image of a bird lighting on a field,[22] it evolved, as Bacon allowed a sort of automatism to intervene, into a study of a

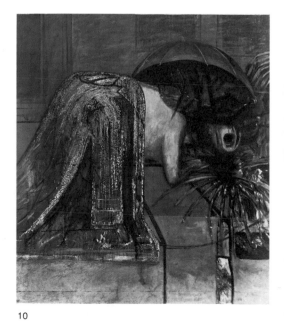

10

powerful, brooding figure who presides with dark ceremony over a scene of slaughter. The attenuated neck and lowered head of earlier paintings is gone now; this figure's neck is huge and bulllike, his upper lip vivid red, as if stained with the blood of the raw meat on the railing. The figure probably reflects Bacon's familiarity with news photos of Joseph Goebbels, Heinrich Himmler, and Benito Mussolini, as well as of Franklin Roosevelt in his cape at Yalta.[23] The umbrella, familiar in Surrealist paintings and in the daily life of England, calls to mind the wartime figure whose emblem it became: Neville Chamberlain, the man who so disastrously misread Hitler. But the imagery transcends the associations of its specific sources, as the figure becomes finally a universal type—an embodiment of autocratic power and brutality.

The composition of *Painting 1946* ironically parallels the conventions of the European formal portrait, and the sumptuous setting has a perversely regal or religious atmosphere. But in place of the ornate Baroque throne of the papal or state portrait is a split carcass, suspended like a crucified human body. Swags festoon the grim scene above, while below, a railing skewered with meat encloses the snarling figure. This sleek, tubular structure—descended from a chrome and glass coffee table designed by Bacon in the late 1920s—serves as a vehicle of "display" for the meat while "articulating the figure in space."[24] While the side of meat recalls those painted by Rembrandt and Chaim Soutine, its handling here is unprecedented, juxtaposed as it is with the ferocious figure.

Painting 1946 was purchased by dealer Erica Brausen, who had visited Bacon's studio shortly after the painting was completed, at the suggestion of Graham Sutherland. Two weeks later, his finances bolstered by the sale, Bacon set off for Monte Carlo, where he made his home for the next four years.[25] During this time he made periodic forays into the casino and painted very little, returning only intermittently to London. Bacon has recalled:

When I was never able to earn any money from my work, I was able sometimes in casinos to make money which altered my life for a time, and I was able to live on it and live in a way that I would never have been able to if I had been earning it. . . . I remember one afternoon . . . I was playing rather small stakes, but at the end of that afternoon chance had been very much on my side and I ended up with about sixteen hundred pounds, which was a lot of money for me then. Well, I immediately took a villa, and I stocked it with drink and all the food that I could buy in, but this chance didn't last very long, because in about ten days' time I could hardly buy my fare back to London from Monte Carlo. But it was a marvellous ten days and I had an enormous number of friends.[26]

No paintings survive from 1947, but late in 1948 (the year that Alfred Barr purchased *Painting 1946* for the Museum of Modern Art in New York) and throughout 1949, Bacon completed a series of six Heads in preparation for a one-man exhibition in November–December 1949 at Brausen's Hanover Gallery in London. As their title suggests, it was in these relatively small canvases that Bacon isolated the mysterious central element that had remained tanta-

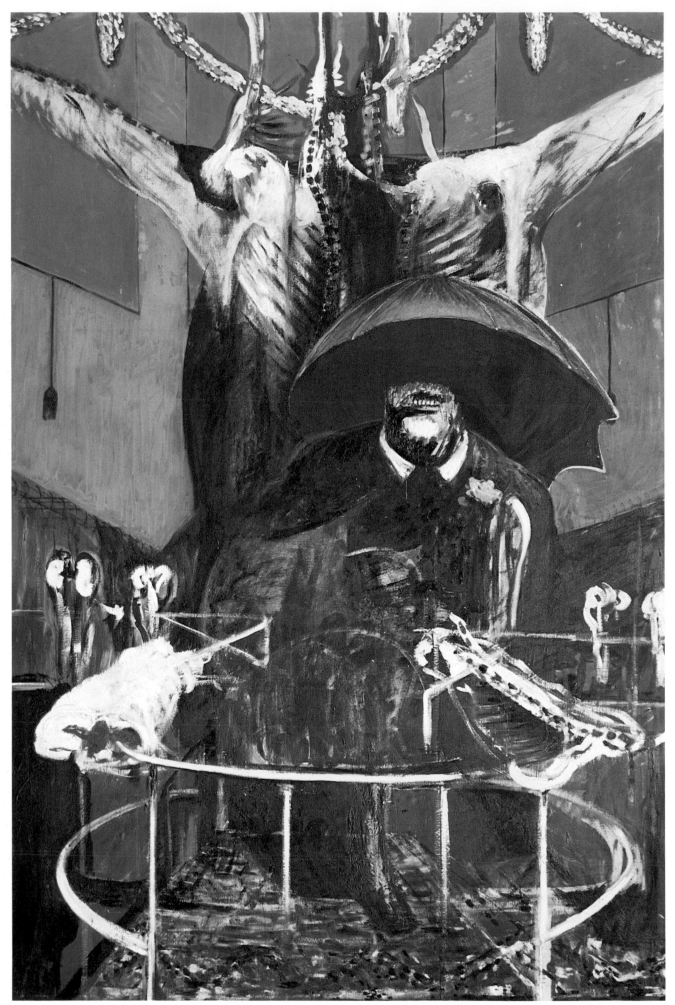

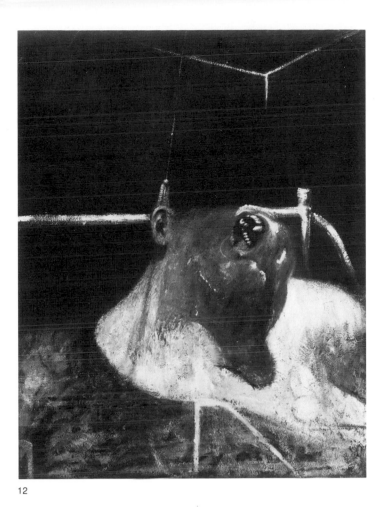

12

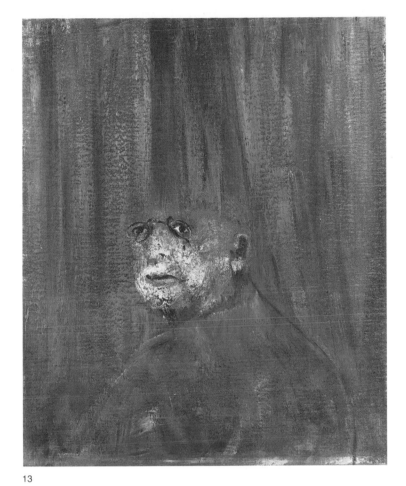

13

lizingly shadowed in his postwar work. In the course of a year, the primeval skull of *Head I* metamorphosed into the papal portrait of *Head VI*. In *Head I* elements of traditional portraiture coexist with loose, spontaneous brushwork. The gold railing (which anticipates the thrones in the papal variations of 1951), the pentimento of a human head (which coincides with the realistic ear surmounted by a tassel), and the suggestion of shoulders indicate that the painting was conceived as a portrait. But the automatic painting process that produced the worked-over passage of white, gray, and black in the lower area subsumed the original head, transforming it into an indistinct form with a savage mouthful of teeth punctuated by fangs.

In *Head III* the hazy image of a man looking over his shoulder floats as though projected on a heavy curtain. This apparition stares penetratingly at the viewer, in Bacon's first rendering of eyes since the early 1930s. As though to make this diaphanous figure more substantial, in *Head VI* Bacon created a cubelike structure that frames and "concentrates"[27] the human subject. Described in rapid, economical strokes, the figure screams in the seclusion of the claustrophobic space, recalling Albert Camus's *L'Etranger*, Sartre's *Huis clos*, and Arthur Koestler's *Darkness at Noon*, in which the authors, as John Russell has observed, "had all seen the small, enclosed, windowless space as a metaphor for our general predicament." With this painting Bacon introduced the imagery that would dominate his work for the next eight years: a figure isolated in

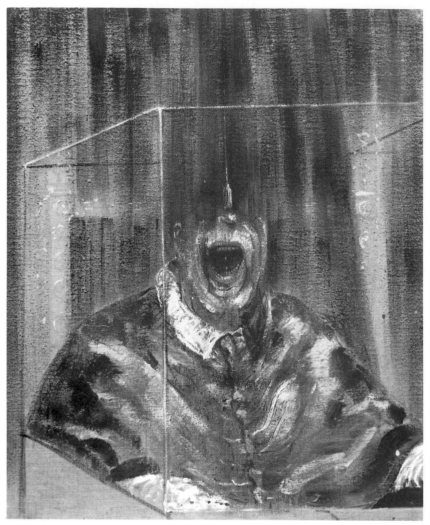

14

a room, unaware of being observed, at a moment of crisis or collapse.[28]

The solitude of Bacon's subject contrasts markedly with the public settings of the images that inspired him. The shrieking figure in *Head VI*, pince-nez barely visible in the haze of gray paint that obliterates the upper half of the face, descends from the nurse on the Odessa Steps in Sergei Eisenstein's 1925 film, *The Battleship Potemkin*, and from Velázquez's *Portrait of Pope Innocent X* of 1650. Bacon has seen the Eisenstein film many times since his first viewing in 1935 and has kept in his studio a close-up photograph of the panic-stricken nurse the instant after she has been shot in the eye and lost control of the perambulator containing the child in her charge. Entrapped as much as enthroned and attired in papal garb, the subject of *Head VI* is Bacon's first interpretation of the Velázquez painting, which he knew only in reproduction.[29]

Study for Portrait (Man in Blue Box) of 1949 is more literal than the mysterious Heads with which it was shown in the Hanover Gallery show. Wearing coat and tie and seated in what appears to be a glass booth, the figure shakes as though illustrating an interrogation scene in George Orwell's *1984*. The image is unusual in

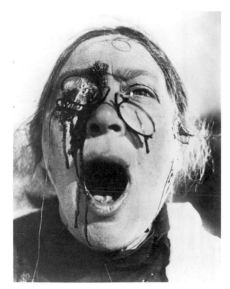

15

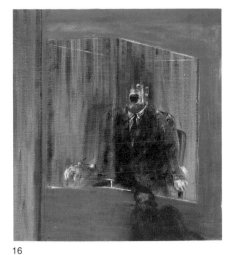

16

17

14. *Head VI*, 1949
Oil on canvas, 36¾ x 30¼ in.
The Arts Council of Great Britain

15. Still of the screaming nurse from Sergei
Eisenstein's *Battleship Potemkin*, 1925
The Museum of Modern Art, New York;
Film Stills Archive

16. *Study for Portrait (Man in Blue Box)*, 1949
Oil on canvas, 58 x 51½ in.
Museum of Contemporary Art, Chicago;
Gift of Joseph and Jory Shapiro

17. *Fragment of a Crucifixion*, 1950
Oil and cotton wool on canvas, 55 x 42¾ in.
Stedelijk van Abbemuseum, Eindhoven,
Netherlands

Bacon's oeuvre because of its narrative innuendoes, with the shadowy foreground figure implying the presence of a tormentor.

Critics interpreted the Hanover Gallery exhibition as exemplifying the postwar mood and reflecting the impact of Surrealism and existentialism. *Time* magazine cited the artist's own remarks: "Horrible or not, said Bacon, his pictures were not supposed to mean a thing. ' . . . Painting is the pattern of one's own nervous system being projected on canvas.'"[30]

As Bacon had updated the image of Pope Innocent X in *Head VI*, so in *Fragment of a Crucifixion* of the following year did he secularize the Crucifixion. Pursued by a creature climbing over the blue cross, the shrieking figure in flight from this scene of agony could not be farther from the traditional image of the tragic savior at the moment of ultimate sacrifice. In the distance, figures and cars move along a street near the sea, oblivious to the suffering figure scarcely out of earshot. (This mundane, postcardlike Mediterranean background is probably explained by the fact that Bacon was living in Monte Carlo at the time.)

17

The open mouth of the terrified victim, the T-shape of the cross, and the figure leaning over the crossbar link Bacon's painting with Rubens's *Descent from the Cross* in the Courtauld Institute Galleries, London. But the mouth loosely opened by death in the seventeenth-century painting is taut in Bacon's image. The legs folded out of view and the left arm passively outstretched by Rubens are transposed by Bacon into violent motion, flapping wildly up and down. The blurred appearance and odd doubled-over pose of the pursued figure in *Fragment of a Crucifixion* may well have been suggested by photographs of human movement. Amid the clutter of images accumulated in Bacon's studio at this time was a clipping of people rushing for shelter during street fighting in 1917 in Petrograd. John Rothenstein recorded Bacon's response to this image: "Not one of these hundreds of figures looks remotely like a conventional figure; each one, caught in violent motion, is stranger and at first sight less intelligible than one could possibly have imagined it."[31]

The depiction of successive stages of motion within a single image, as in Bacon's rendering of the flapping arms, had been explored by Georges Seurat in *La Chahut* of 1889–90, by the Futurists, and by Marcel Duchamp in the *Nude Descending a Staircase (No. 2)* of 1912. These painterly descriptions of movement were likely influenced by the stop-action photographs taken by Etienne-Jules Marey beginning in 1881.[32] But while the technical model for the winglike arms might well have been one of Marey's photographs of a gull in flight, the source of inspiration for enlisting this image as an expression of terror is less easy to pinpoint. The fleeing figure may reflect the impact of a passage from Karen Blixen's *Out of Africa* of 1937. Bacon has read this moving account of the author's life on a farm in Kenya several times and must have been struck by her straightforward description of a shooting accident:

He was sitting up, leaning forwards, towards the lamp; the blood spouted, like water from a pump, from his face,—if one could still say that, for he must have stood straight in front of the barrel when it was fired and it had taken his lower jaw clean off. He held his arms out from his sides and moved them up and down like pump-spears, as the wings of a chicken go, after it has had its head cut off.[33]

In 1966 Bacon claimed that he used the Crucifixion because "I haven't found another subject so far that has been as satisfactory for covering certain areas of human feeling and behaviour. . . . I think that this may be that we live in a period where we're rather lacking in a contemporary myth."[34] Conceived in the light of Nietzsche's declaration that "God is dead," this image of the Crucifixion has become an existential statement about suffering and persecution.

The worked-over surfaces and harsh, solid color of Bacon's paintings of the early 1940s had eased by 1950. Nearly two-thirds of the surface of *Fragment of a Crucifixion* is raw canvas. Color is subdued: the palette of muted blue, white, and black suggests black and white photographic prints; the blurred handling con-

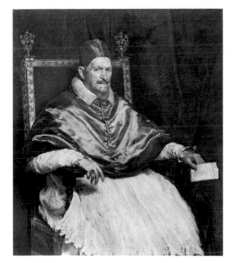

18

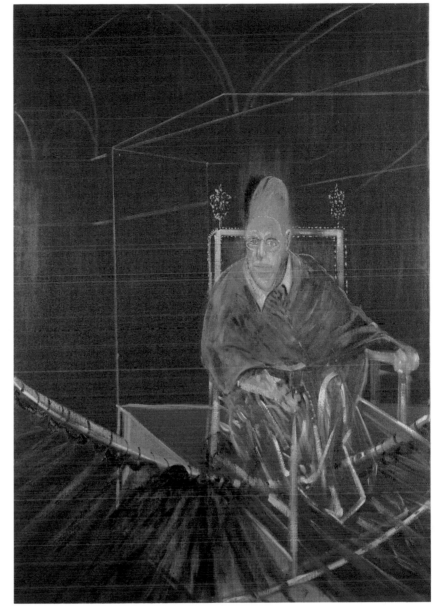

19

18. Diego Rodriguez de Silva Velázquez
Portrait of Pope Innocent X, 1650
Galleria Doria Pamphili, Rome

19. *Pope I,* 1951
Oil on canvas, 78 x 54 in.
Aberdeen Art Gallery and Museum,
Aberdeen, Scotland

jures up the impression of movement and volume. The linear style derived from Picasso, which had culminated in the Tate triptych, was rejected in favor of the more painterly approach of the Head series.

The Heads pointed the direction for Bacon's work of the 1950s, which is dominated by studies of single figures in hazily described interiors. "Haunted and obsessed by the image, . . . by its perfection,"[35] Bacon sought to reinvent Velázquez's *Portrait of Pope* 18 *Innocent X* in more than twenty-five images, painted throughout the decade, that descended from *Head VI.* As Bacon began to anticipate more consistent exhibition of his work, he became increasingly prolific, at the same time destroying fewer paintings. While only fourteen finished works survive from the six years after the Tate triptych of 1944 (seven of which were produced during

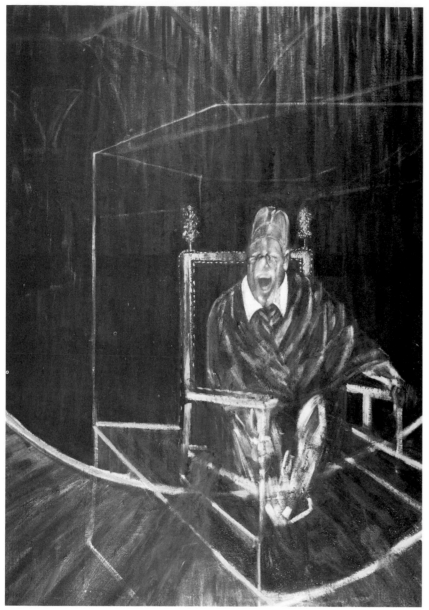

20

the ten months before his first one-man exhibition), between 1951 and 1957 Bacon completed more than 110 paintings.

While Velázquez had depicted the public persona of the most powerful man of his day, Bacon, not fettered by the constraints of a commission, chose to strip away the "veils of appearance"[36] to reveal the screaming human being within. Velázquez's *ex cathedra* image of the pope was recast by Bacon *in camera*. The vestigial attributes of the pope appear in Bacon's series like the costumes in a Jean Genet play.

19–21 *Popes I, II,* and *III,* painted during the fall of 1951, constitute Bacon's first papal series. While the figure derives from Velázquez's painting, the dark ecclesiastical setting was drawn from a contemporary photograph of Pope Pius XII. The monochromatic tone and veiled insubstantiality of these paintings approximate the look

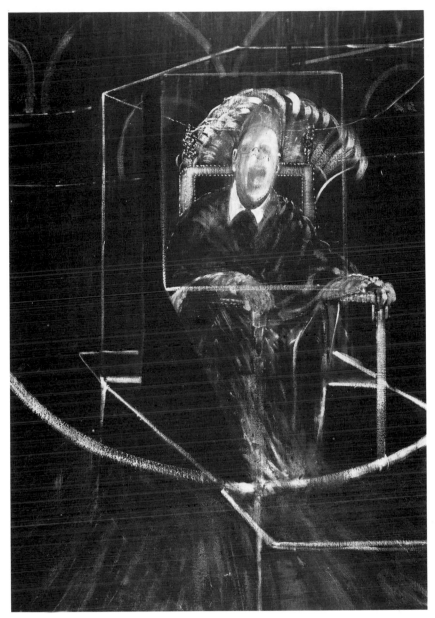

21

20. *Pope II*, 1951
Oil on canvas, 78 x 54 in.
Stadtische Kunsthalle, Mannheim

21. *Pope III with Fan Canopy*, 1951
Oil on canvas, 78 x 54 in.
Destroyed

of newspaper photographs, whose immediacy appealed to Bacon. The three paintings represent his first effort to show the successive actions of a single figure in a series of works.[37] *Pope I* is a relatively static image, the face of *Pope II* is blurred, and *Pope III*'s features are almost indistinguishable. A semicircle of peacock feathers behind *Pope III*'s head—adapted from the same photograph of Pope Pius XII—agitates the image, as though echoing the vibrations of the pope's full-blown cry. When this papal series was exhibited in 1951–52 at the Hanover Gallery, critics proposed that the pope had been strapped into an electric chair. But Bacon observes that his open-mouthed subjects might just as well be yawning, coughing, sneezing, laughing, or talking and notes that "I've always been very moved by the movements of the mouth and the shape of the mouth and the teeth. People say that these have all

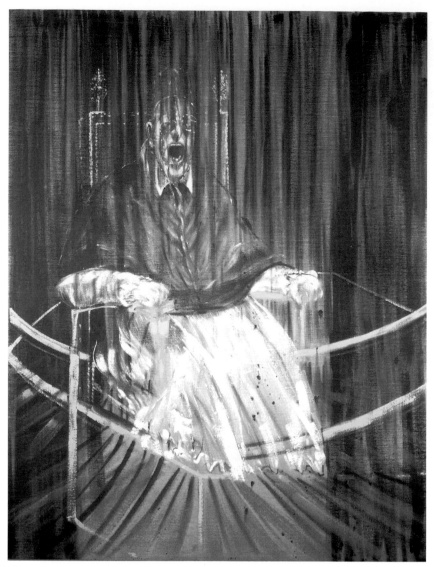

22

sorts of sexual implications, and I was always very obsessed by the
actual appearance of the mouth and teeth, and perhaps I have lost
that obsession now, but it was a very strong thing at one time. I
like, you may say, the glitter and colour that comes from the
mouth. . . ."[38]

22 With the *Study after Velázquez's Portrait of Pope Innocent X* of
1953, Bacon reinvented Velázquez's image both formally and
thematically by tempering the composed grandeur and distant self-
confidence of the seventeenth-century painting with the blurred
spontaneity and instability of the twentieth-century photograph.
Retaining the structure of the staid Baroque prototype—the pose,
the attire, the throne, and the setting—he tightens the relaxed
hands into balled fists and incorporates the open mouth and man-
gled pince-nez from Eisenstein's screaming nurse. The blood-
spattered robe—a touch suggested by the Eisenstein shot—parallels

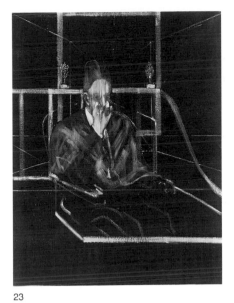

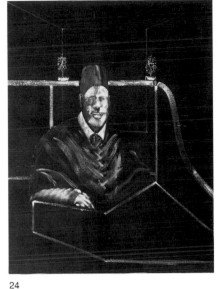

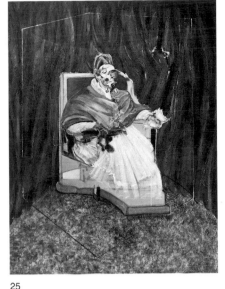

23

24

25

22. *Study after Velázquez's Portrait of Pope Innocent X*, 1953
Oil on canvas, 60¼ x 46½ in.
Des Moines Art Center, Des Moines, Iowa;
Coffin Fine Arts Trust Fund, 1980

23. *Study for Portrait IV*, 1953
Oil on canvas, 60 x 45¾ in.
Vassar College Art Gallery, Poughkeepsie,
New York; Gift of Blanchette Hooker
Rockefeller '31

24. *Study for Portrait V*, 1953
Oil on canvas, 60⅛ x 46⅛ in.
Hirshhorn Museum and Sculpture Garden,
Smithsonian Institution, Washington, D.C.

25. *Study for Portrait of Pope Innocent X*, 1965
Oil on canvas, 78 x 58 in.
Private collection, Scotland

the intuitive gesture of a Jackson Pollock drip. Extending Titian's mysterious use of a veiling curtain in the *Portrait of Cardinal Filippo Archinto* of about 1558, Bacon succeeds in painting "a head as if folded in on itself, like the folds of a curtain."[39]

So compelling was the image of the pope for Bacon that a portrait of his friend the art critic David Sylvester had, by the end of the fourth sitting during the summer of 1953, become a picture of the pope entitled *Study for Portrait I*. In the two weeks following this transformation Bacon completed seven variations of the work, *Studies for Portrait II* through *VIII*,[40] chronicling the mounting distress of the figure. The formal composure of *Portrait I* gives way to the fidgeting, sneezing, laughing, and screaming of successive images that culminate with an "Italian salute" in *Portrait VIII*. A critic wrote incisively of these works: "Technically, Bacon has been audacious enough to try for one continuous cinematic impression in his . . . Popes—an entirely new kind of painting experience. He combines the monumentality of the great art of the past with the 'modernity' of a film strip."[41] Bacon was certainly inspired in this technique by photography. While film footage and contact sheets might have triggered his use of seriality, most likely his crucial model was the collection of multiple-image photographic studies of the 1880s contained in Eadweard Muybridge's book *The Human Figure in Motion*.[42] Bacon was intrigued by Muybridge's photographs at this time, and two seminal works of 1952 and 1953, *Study for Crouching Nude* and *Two Figures*, are closely related to the photographer's work.

Although Bacon created several studies of the pope over the next decade, he had tired of the subject by late 1953.[43] Twenty years later he looked back disparagingly on the images after Velázquez's *Pope Innocent X*, reflecting that "it's already so remarkable that there's nothing to do about it, but I was hypnotized, at that time, by the beauty of it."[44] The underlying theme of the

23, 24

28, 36

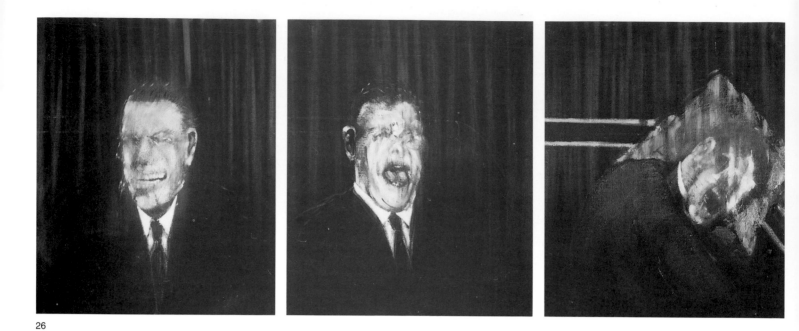

26

paintings of men dressed in business suits that follow the popes remained the private disintegration of the public image.

26 *Three Studies of the Human Head*, painted in August–September of 1953, was not initially conceived as a series, and the third was actually the first to be painted.[45] Yet they became Bacon's first triptych exploration of the human head and document the mounting excitement of the figure, his mouth opening wider and his face increasingly wild and blurred as he collapses. The image of the scream, which had been central to Bacon's work since the Tate triptych of 1944, dwindled in importance after 1953. Subsequent figures, often seated in desk chairs and set within sparsely described rooms, became for the most part more silent and controlled, as in 27 *Study for Portrait IX* (1957). By 1966 Bacon could reflect: "I did hope one day to make the best painting of the human cry. I was not able to do it. . . ." By 1973 Bacon had lost interest in the melodrama of the subject:

When I made the Pope screaming, I didn't do it in the way I wanted to. I was always . . . very obsessed by Monet. . . . Before that, I'd bought that very beautiful hand-colored book on diseases of the mouth, and, when I made the Pope screaming, I didn't want to do it in the way that I did it—I wanted to make the mouth, with the beauty of its colour and everything, look like one of the sunsets or something of Monet, and not just the screaming Pope. If I did it again, which I hope to God I never will, I would make it like a Monet.[46]

As the scream of the seated figure faded in Bacon's work, the artist turned with fresh energy to consider the expressive potential of the postures and movements of the nude figure. Stripped of pretense as well as of clothes, the crouching and embracing nudes of the 1950s reflect Bacon's fascination with Muybridge's studies of human and animal movement. Like the figures in Bacon's Cruci-

fixion and papal images, the subject of the *Study for Crouching* 28
Nude of 1952 is elevated, balanced on a railing that recalls the
one in *Painting 1946* and framed by a skeletal cube echoing those
in the paintings of popes and businessmen.

In contrast to the stately if crumbling façades of the popes, the
subject of *Study for Crouching Nude* is shown in a compact pose
that ambiguously suggests the fetal position, the stance for defeca-
tion, and—as seen more clearly some twenty years later, in *Triptych* 75
May–June (1973)—the position assumed in death. The antithesis
of the classical open pose of an erect, heroic subject, this closed,
primeval bearing suggests hunkering primates or cavemen squatting
around a fire. Calling to mind naked men locked away in anony-
mous, windowless cells, this figure conveys the introspection,
regression, and withdrawal associated with prison or asylum
inmates, the quintessential posture of man divested of civilization.
The evocative richness of the image belies the banality of its origins.
The figure was modeled on Muybridge's photographs of *Man* 29

26. *Three Studies of the Human Head*, 1953
Oil on canvas, triptych, each panel 24 x 20 in.
Private collection

27. *Study for Portrait IX*, 1957
Oil on canvas, 59½ x 49½ in.
Abrams Family Collection

27

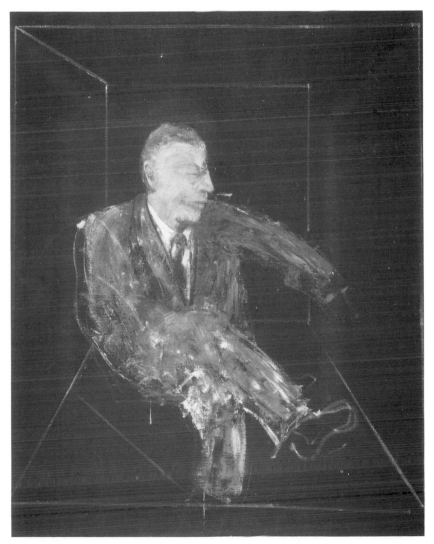

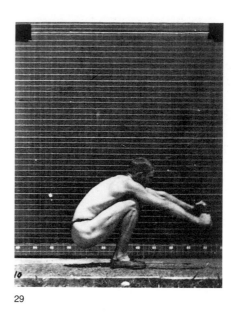

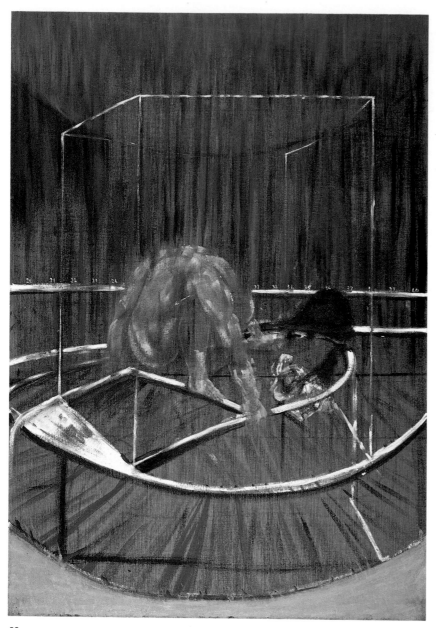

28

28. *Study for Crouching Nude*, 1952
Oil on canvas, 78 x 54 in.
The Detroit Institute of Arts;
Gift of Dr. Wilhelm R. Valentiner

29. Eadweard Muybridge, *Man Performing Standing Broad Jump*, from *Human Figure in Motion*, c. 1885
New York Public Library, General Research Division; Astor, Lennox, and Tilden Foundations

30. *Man Kneeling in Grass*, 1952
Oil on canvas, 78 x 54 in.
Dr. Vittorio Olcese, Milan

31. *Study of a Figure in a Landscape*, 1952
Oil on canvas, 78 x 54 in.
The Phillips Collection, Washington, D.C.

32. *Study of a Baboon*, 1953
Oil on canvas, 78⅛ x 54⅛ in.
The Museum of Modern Art, New York;
James Thrall Soby Bequest

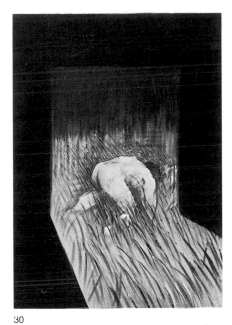

30

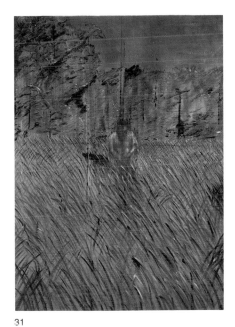

31

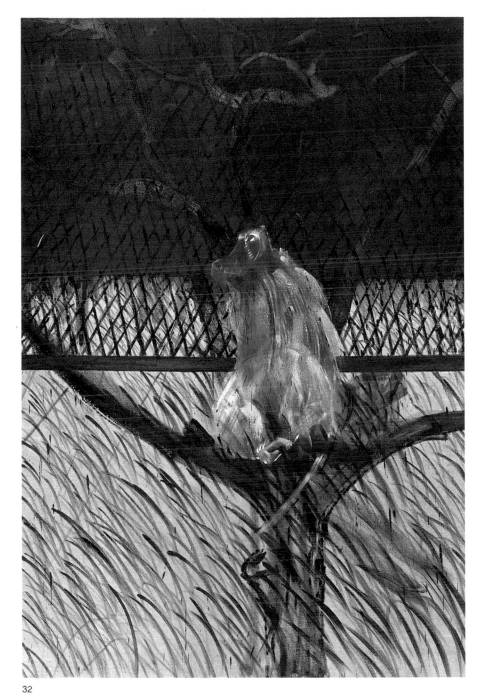

32

Performing Standing Broad Jump, with the photographer's measuring scale reiterated in the numerals evenly spaced along the horizontal band that bisects the composition.

Bacon explored the image of the crouching nude set outdoors in 30 *Man Kneeling in Grass* of the same year. The vertical "curtain" lines that encircle the *Study for Crouching Nude* are here consigned to the background; the lines fanning out beneath the *Crouching Nude* have become a field of grass. In place of the circular space that envelops the earlier nude, Bacon has created dark passages of wall and floor that frame and compress the grassy setting. While 8 tall tufts of grass had first appeared in the Tate triptych (1944), the immediate stimulus for the windblown grass—painted in arc-shaped gestural strokes—was Bacon's experience of the landscape of South Africa during a visit in late 1950 and early 1951 and another in the spring of 1952.

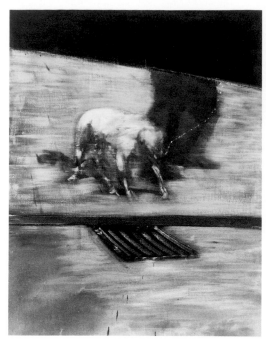

33

Bacon augmented his firsthand experience of the landscape and animals of such places as Kruger Park by referring to the photographic plates of Marius Maxwell's *Stalking Big Game with a Camera in Equatorial Africa* (1924).[47] In pursuit of his dangerous subjects, Maxwell had been forced to act quickly, and many of the resultant images have a blurred, dreamlike insubstantiality that must have appealed to Bacon. The grassy habitat became the set- 32 ting for the *Study of a Baboon* (1953), its subject's jaws opened wide, yawning or screaming like the popes that preceded it. Pressed toward us, rather than separated from us, by the fence that veils the branches and landscape beyond, this wild creature seems to share with us the landscape space of a zoo or game preserve.

Bacon created a trio of straight landscape images in 1952, but dismisses them as the result of an "inability to do the figure," relegating landscape to the bottom of a hierarchy: "portraits come first" and then animals.[48] While Bacon apparently reiterates here the hierarchy of subject matter that prevailed from the Renaissance into the nineteenth century, in fact he rejects what was traditionally the most important category, history painting, which supplies with its often mythological or religious content the continuities of narration. "I think that the moment a number of figures become involved, you immediately come on to the story-telling aspect of the relationships between figures. . . . I always hope to be able to make a great number of figures without a narrative."[49]

The natural habitat of the African-inspired landscapes contrasts markedly with the hard, abstractly architectural settings of Bacon's Dogs and Sphinxes of 1952–54. While his interest in painting animals—among them an elephant and a rhinoceros—undoubtedly reflected his experience in Africa, the Dogs were drawn from a sequence of Muybridge photographs entitled *Dread Walking*. Though Muybridge's photographs are almost always sharply defined, in several of these images the mastiff's head is shadowed and out of focus; it was to these particular views that Bacon 33 turned.[50] In *Man with Dog* (1953) the ghostly dog is linked by a leash to a shadowy figure suggested only by the hazy outline of legs and feet. The pair walk along a pavement beside a curb and sewer grate, a dark wall behind them cutting diagonally across the picture like the background grid of the Muybridge photograph. In

33. *Man with Dog*, 1953
Oil on canvas, 59⅞ x 46½ in.
Albright-Knox Art Gallery, Buffalo, New York;
Gift of Seymour H. Knox, 1955

34. *Sphinx I*, 1953
Oil on canvas, 78½ x 54 in.
Private collection, California

35. *Dog*, 1952
Oil on canvas, 78¼ x 54¼ in.
The Museum of Modern Art, New York;
William A. M. Burden Fund

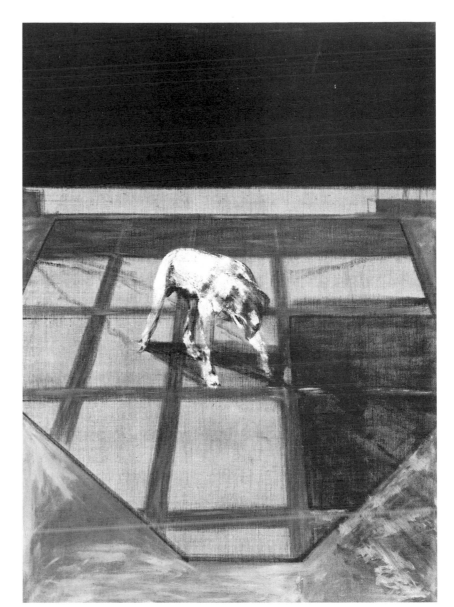

35

their elusiveness the dog and man recall the moving figures whose
fleeting presence was recorded in early slow-exposure photographs.
The hexagonal setting of *Dog* (1952) reappears in *Sphinx I* (1953). 35, 34
Like a regal reincarnation of Dread, the sphinx stretches out
commandingly, its transparency making it seem as insubstantial as
the shadow of a man with pointed gun that appears to the right.
This intimation of a figure of violence looks ahead to the strangely
palpable shadows associated with images of death in the 1970s.

In 1953 Bacon turned to "an endless . . . a very haunting
subject"[51] that has appeared repeatedly in his work of the past
three decades. In *Two Figures* (1953) the bedroom took its place 36
alongside the papal chamber with Bacon's first painting of two
figures making love. *Two Figures* is perhaps his most significant
and enduring adaptation of a Muybridge photograph. It seems

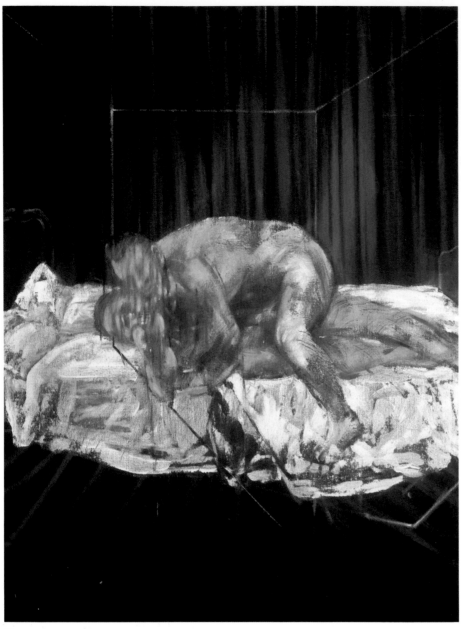

36

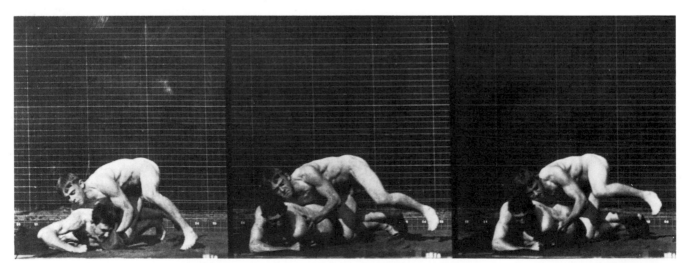

likely that Bacon, prompted by personal experience, first decided to paint the subject, then recollected or sought out the Muybridge photograph of *Men Wrestling* as a model. "I very often think of people's bodies that I've known, I think of the contours of those bodies that have particularly affected me, but then they're grafted very often onto Muybridge's bodies."[52] Taking that dispassionate imagery as his starting point, Bacon then pressed his subject matter ever closer to his own life. As he has mused, "The everyday wash of life flows into one's whole imagery, and that mingled with instinct and chance brings up images. I use the whole of my experience and I know this all goes into the work, not consciously, but it goes into all the imagery."[53]

By the spring of 1956 the grisaille palette and detached vantage point of photography had receded in importance for Bacon as he turned for inspiration to the vehement color and expressionist subjectivity of Vincent van Gogh. A series of eight variations on van Gogh's *The Painter on the Road to Tarascon* (1888), painted during 1956 and 1957, chronicle the emergence of heightened color and freer handling in Bacon's painting. At a time when artists such as Richard Hamilton were exploring the hard-edged style of commercial art, Bacon built up surfaces and loosened the edges of forms. Working from a reproduction of van Gogh's late self-portrait,[54] Bacon created the initial, darkest work of the series early in 1956, before setting off for the first of many visits to Tangier. The blazing Midi sun of van Gogh's painting must have seemed more vivid to Bacon after spending time in a Mediterranean climate, and in the subsequent seven versions, painted in 1957, saturated color is illuminated by a searing light. *Studies for Portrait of van Gogh II, III,* and *IV* were painted very rapidly in March 1957, for inclusion in Bacon's one-man show opening late that month at Hanover Gallery.

Taking his cue from the diagonal established by the artist and his shadow in the painting of 1888, in the second variation Bacon tilts the road, intensifying the effect of instability created by the harsh palette and the tumultuous application of paint. As if to steady himself against the treacherous incline, the figure plants his walking stick behind him. Charred by the infernal heat, the trees beyond the artist offer no shelter, seeming to be victims themselves of the force that drags the lone figure forward. With *van Gogh III* this "haunted figure on the road . . . like a phantom of the road"[55] sinks into the landscape, as figure and ground merge with the painterly facture. His hat extends a field of yellow, his body parallels the trees in color and handling, and his feet virtually melt into the seething road.

Unlike the Surrealistic conflations of Bacon's earlier work, the van Gogh studies are expressionist explorations of a single art historical image and mark a moment of transition in Bacon's work. The next year, 1958, was one of reflection, during which Bacon produced only six surviving paintings. He left the Hanover Gallery, signing a contract with Marlborough Fine Art Ltd. that October.

In February–March 1959 an exhibition called *The New American Painting*, including works by such color-field painters as Barnett Newman and such gestural painters as Willem de Kooning, was

presented at the Tate Gallery. Though Bacon feels little affinity with the Abstract Expressionists, declaring that Pollock's work looks like "old lace,"[56] he must have been impressed by the clear, open passages of flat, vivid color of Newman's work and by the spontaneity of de Kooning's and Pollock's brushwork. The spare settings of Bacon's group of reclining figures of 1959 have no precedent in his own work and diverge drastically from the vehemently brushed backgrounds of the van Gogh variations. It is as though floodlights washed the walls of Bacon's once murky interiors, now saturated with the intense colors of the van Gogh paintings. The bands of wall, curving couch, and carpet of *Reclining Figure* (1959) serve as a clearly painted foil for the loosely handled, emblematic nude, reclining in a posture of abandon.

The opportunity to see an exhibition of Abstract Expressionism brought sharply into focus for Bacon his differences from that movement. The women of de Kooning, transcending specificity to become goddesslike, seemed to Bacon like "playing cards,"[57] while the abstraction of color-field and gestural painters alike appeared

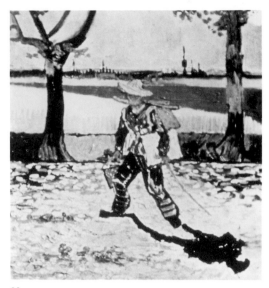

39

38

hopelessly remote from life. From Bacon's point of view, abstraction is at its core merely aesthetic, lacking the resonance of work linked more directly to the human image. The spiritual content of much Abstract Expressionist painting, discussed in writings by such artists as Newman, Mark Rothko, and Adolph Gottlieb, failed to convince Bacon, whose commitment to more visceral, figurative imagery remained firm.

On both sides of the Atlantic, these masters of postwar painting had set the stage, if inadvertently, for a younger generation of artists. Just as de Kooning's incorporation in *Study for Woman* (1950) of a collaged mouth clipped from a Camel cigarette ad has often been cited as providing a starting point for James Rosenquist and other American Pop artists, so Bacon's use of photographic imagery has been credited with suggesting a route for the young painters who would create British Pop art. But just at the moment when artists in England and America were discovering inspiration in the public domain of commercial art, Bacon turned with vigor to increasingly personal subject matter.

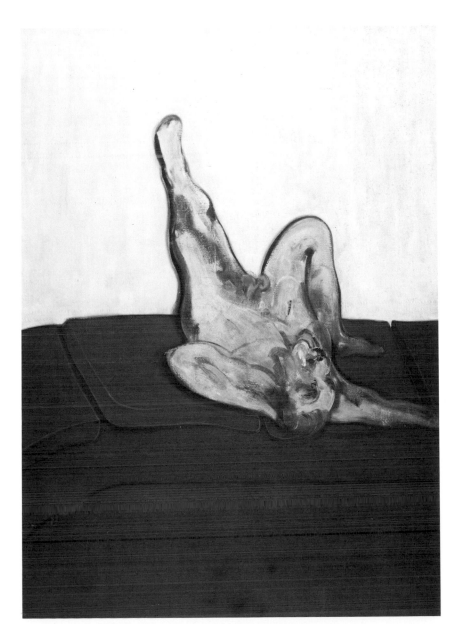

38. *Study for Portrait of Van Gogh III*, 1957
Oil and sand on linen, 78⅛ x 54⅛ in.
Hirshhorn Museum and Sculpture Garden,
Smithsonian Institution, Washington, D.C.

39. Vincent van Gogh
The Painter on the Road to Tarascon, 1888
Destroyed

40. *Reclining Figure*, 1959
Oil on canvas, 78 x 56 in.
Private collection, New York

40

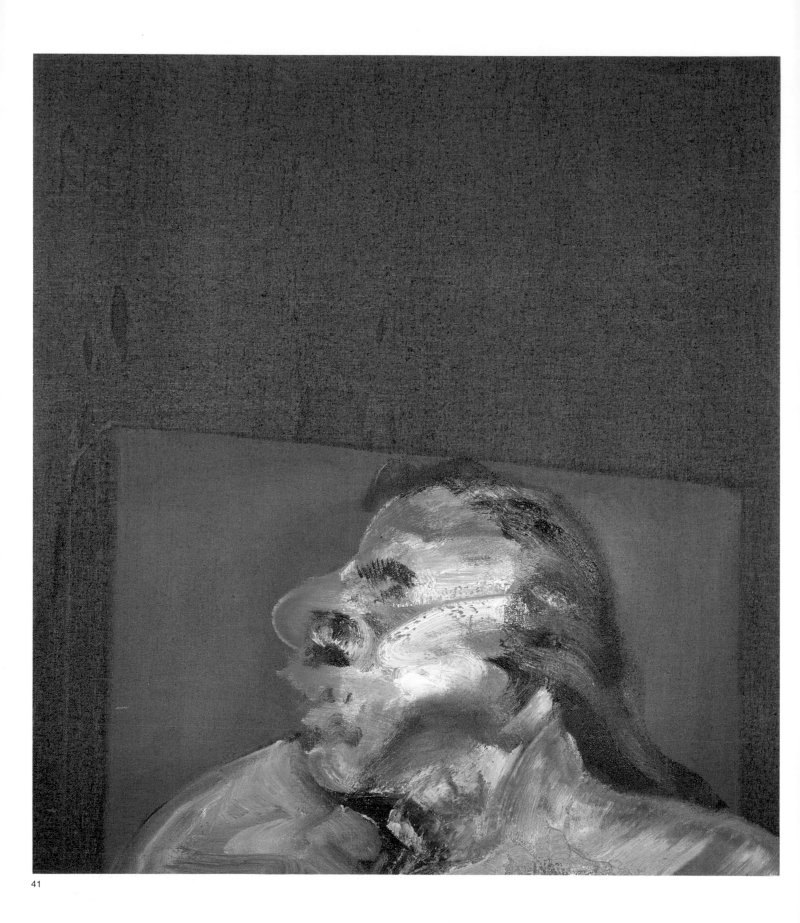

41

2 Images from Life

By the end of the 1950s Bacon had begun more and more to find his imagery within his own life rather than in the remote realms of earlier art. Self-portraits and portraits of his friends started to supplant images after Velázquez and van Gogh. From the start he has worked largely from memory in painting his portraits, which are invariably of close friends. For his self-portraits he has studied himself in mirrors as well as in photographs. Strewn among the images clipped from newspapers and magazines and the reproductions of art (including his own) that litter his studio are photographs of Bacon's portrait subjects, which he uses like cue cards to prompt the paintings. Having searched their gestures and faces, the asymmetries of their postures and smiles, Bacon then prefers to paint in the absence of his subjects:

. . . if I have the presence of the image there, I am not able to drift so freely as I am able to through the photographic image. . . . What I want to do is to distort the thing far beyond the appearance, but in the distortion to bring it back to a recording of the appearance. . . . And I think that the methods by which this is done are so artificial that the model before you, in my case, inhibits the artificiality by which this thing can be brought back.[58]

Muriel Belcher, who presided over London's Colony Club for more than thirty years, became one of Bacon's first portrait subjects, in a profile bust of 1959. Smeared passages of paint, akin to those that describe the anatomy of *Reclining Figure* of the same year, convey the bold bearing of the subject with uncanny accuracy. Tightly framed by the green panel that isolates her from the expanse of darker green above, the lively face of this unflappable friend seems caught in passing, so far does the top-heavy composition stray from the conventions of traditional portraiture. As Bacon sought to capture the likenesses of his friends, his work began to soften somewhat. By the time Adolf Eichmann was convicted of war crimes and the rupture of Germany was cast in the concrete of the Berlin wall in 1961, Bacon had long since left behind the frenzied figures in murky settings that had established his reputation.

41. *Miss Muriel Belcher*, 1959
Oil on canvas, 29 x 26½ in.
Private collection

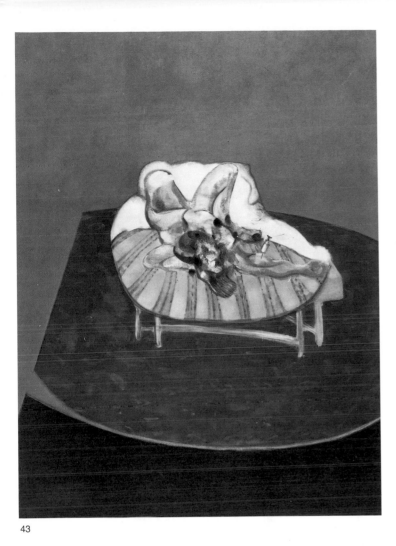

43

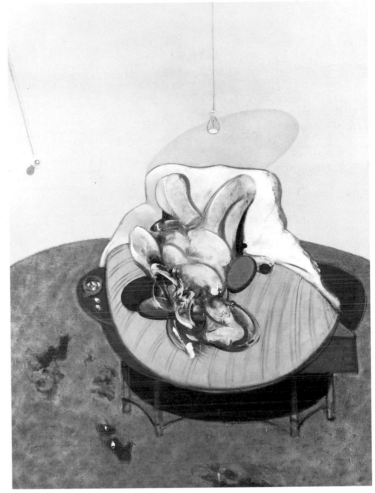

44

42. Detail of plate 44

43. *Lying Figure with Hypodermic Syringe,*
1963
Oil on canvas, 78 x 57 in.
Private collection, Switzerland

44. *Lying Figure,* 1969
Oil on canvas, 78 x 58 in.
Private collection, Montreal

Early in the 1960s Bacon moved into a small apartment above a garage in a mews in Kensington, which has remained his home ever since. Filled with books and photographs, this simple, three-room apartment has an informal look. A visitor first encounters the rudimentary kitchen, which contains the apartment's bathtub, and then discovers the studio to the right and the bed-sitting room to the left. Entering this living space, the visitor is surprised by a floor-to-ceiling mirror facing the doorway; the reflection is disrupted by a network of cracks recalling Duchamp's *Large Glass* (1915–23). Clutter abounds, but decoration is spare—the walls are bare of paintings, the floor rugless. Suspended from the ceiling, bare bulbs with wall and pull-string switches illuminate the room, its windows draped with heavy dark green curtains. The studio is similarly illuminated by bare light bulbs, the only natural light entering through a shaft leading to a skylight. The tools and residue of the artist's work—paint tubes, brushes, magazines, and rags—cover the studio floor.

In 1962 Bacon produced a self-portrait flanked by paintings of a close friend who had died in Tangier that year. Called *Study for Three Heads,* the triptych points the direction for subsequent portraits, as smeared elliptical passages replace the photographic blur of earlier faces. Bacon has observed: "I think if you want to convey fact, this can only ever be done through a form of distortion. You must distort to transform what is called appearance into

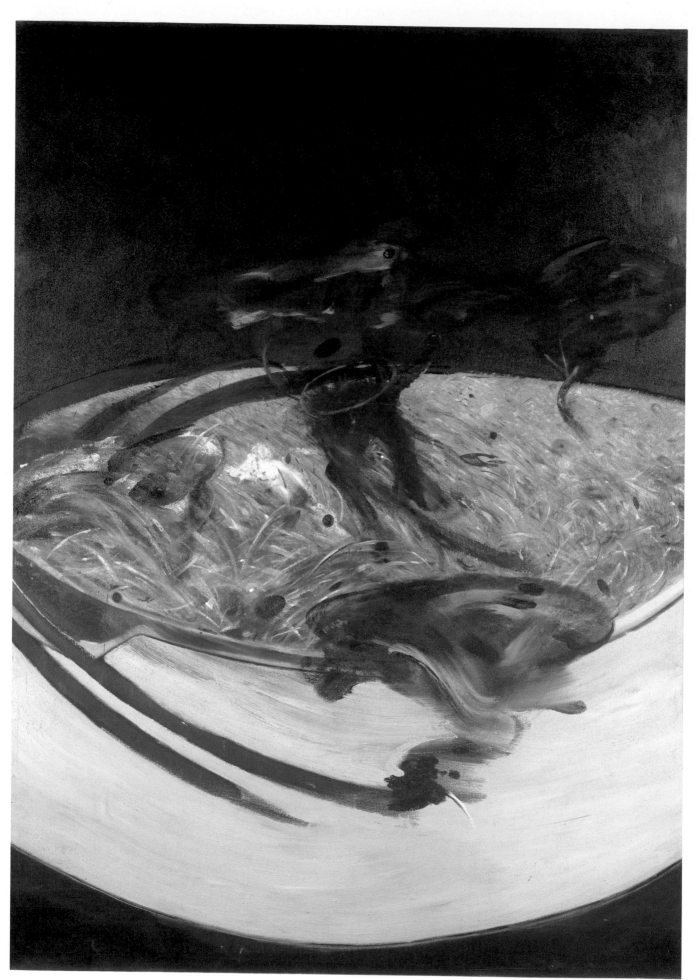

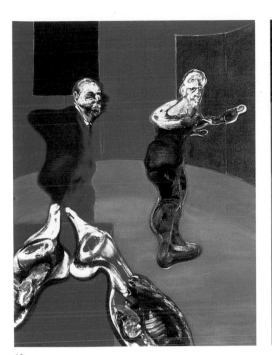
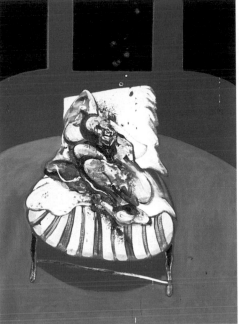
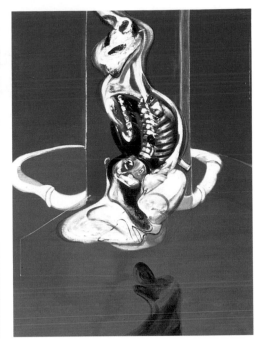

46

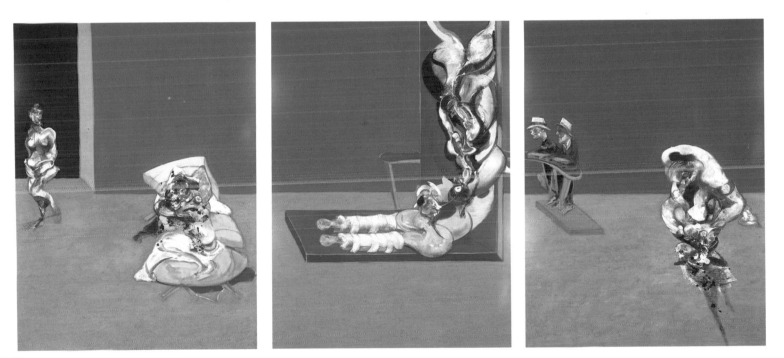

47

45. *Landscape near Malabata, Tangier*, 1963
Oil on canvas, 78 x 57 in.
Private collection

46. *Three Studies for a Crucifixion*, 1962
Oil with sand on canvas, triptych, each panel
78 x 57 in.
The Solomon R. Guggenheim Museum,
New York

47. *Crucifixion*, 1965
Oil on canvas, triptych, each panel 78 x 58 in.
Staatsgalerie Moderner Kunst, Munich;
Gift of the Galerie Vereins, Munich

image."[59] In the late 1950s Bacon had kept an apartment in Tangier, and a particular landscape near Malabata, which had intrigued the painter during his stays in North Africa, became the subject of a turbulent painting completed in 1963. And in paintings from *Lying Figure with Hypodermic Syringe* (1963) onward, the private spaces of Tangier were recalled in rounded beds, with blue-striped covers like mattress ticking, which traced their origins to the sleeping mats of Morocco.[60]

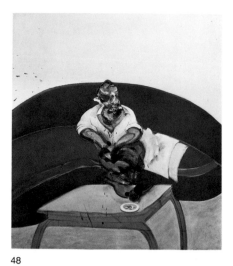

48

The pose of *Lying Figure with Hypodermic Syringe* is descended from *Reclining Figure* (1959), while its composition of banded ellipses is linked with *Landscape near Malabata, Tangier*. The plump bed on which the figure sprawls rests on a mottled red carpet that is tipped up, like the lily ponds of Monet, to read against the magenta ground. The tilt of the figure is made especially dizzying by this collapsing of the space. Calling to mind the anatomical displacements of the Surrealist vagina dentata, Bacon's lying figures seem curiously inverted, heads below, legs and genitals above.[61] The lethargy of the 1959 *Reclining Figure* has given way in *Lying Figure with Hypodermic Syringe* to an even stronger impression of enervation, as the figure's arm is pierced by the syringe of the title. Bacon claims that he used this device as a way of visually "nailing . . . the flesh onto the bed" and rendering the arm a "dead weight."[62] Six years later this subject reappeared in *Lying Figure*, its visceral forms illuminated by a bare light bulb. The riveting detail of the syringe is joined in the later work by cigarette butts that spill from the ashtray onto the bed and floor. The opaque yellow oval around the light bulb recalls the jagged sun encircling the bare bulb in Picasso's *Guernica* of 1937 and augurs the increasing solidity of shadows in Bacon's work of the next decade.

49

The pose of abandon of Bacon's reclining figures ironically parallels the "strung-up" position of the corpses in his Crucifixion triptychs of 1962 and 1965. Expressing the godless, essentially existentialist point of view that has persisted throughout his career, Bacon observed in 1962, "I think that man now realizes that he is an accident, that he is a completely futile being, that he has to play out the game without reason."[63] In light of this conviction and intrigued by the lingering power of this myth in an age lacking belief,[64] Bacon painted the second and third Crucifixions of his career.

The imagery of the Crucifixion is mingled in the artist's imagination with that of the slaughterhouse. The crucified figure of 1962, its anatomy more bovine than human and its grimace revealing canine incisors, recalls the sides of meat that had appeared in Bacon's work of the 1940s and '50s. In *Crucifixion* (1965) the sense of struggle and urgency of the 1962 painting has subsided somewhat: the writhing figure has become a stiff-limbed carcass with splintlike bandages that suggest the frilly paper collars used by butchers to dress up joints of meat. "I've always been very moved by pictures about slaughterhouses and meat, and to me they belong very much to the whole thing of the Crucifixion. There've been extraordinary photographs which have been done of animals just being taken up before they were slaughtered; and

the smell of death." It is perhaps the futility of their struggle against certain death that has seemed most poignant to Bacon.

We don't know, of course, but it appears by these photographs that they're so aware of what is going to happen to them, they do everything to attempt to escape. I think these pictures [of the Crucifixion] were very much based on that kind of thing, which to me is very, very near this whole thing of the Crucifixion. I know for religious people, for Christians, the Crucifixion has a totally different significance. But as a non-believer, it was just an act of man's behaviour, a way of behaviour to another.[65]

In the 1962 work two men—tormentors, witnesses, or fellow victims, perhaps—loom large at left. The bone forms that intrude into the space at lower left are echoed within the same panel in the hands of the man at right, who seems irreparably wounded and impotent. These lurid figures have been replaced in the 1965 painting by a pair of men at an altar or bar, their hats giving them a distinctly underworld air. Recalling the two thieves who shared Christ's fate on Golgotha are brutalized figures wearing rosettes, like those adorning good cuts of meat, which punningly mimic the Royal Air Force insignia. An aggressively muscular arm surmounting the bruised figure at right wears a Nazi armband. Bacon later regretted the literal reading suggested by this confrontation of World War II symbols, declaring that the armband had been inserted to "break the continuity of the arm and to add that particular red round the arm."[66] Looking back in 1973, Bacon noted that he had thoroughly exhausted the possibilities of the Crucifixion theme: "I would never use it or could never use it again because it's become—it was always dried up for me—but it's become impractical even to use it."[67]

The blood-spattered and bullet-riddled bodies of Bacon's Crucifixions shocked audiences in London and Europe just at the moment when the apparent dispassion of Andy Warhol's Disaster paintings was unnerving a public numb even to its own detachment from the televised tragedies on the evening news. Twenty years later, Bacon's depictions of the apparently senseless suffering of the Crucifixion seem less distant from Warhol's insistently repetitive images of random death than they once did. For while the raw violence of Bacon's paintings has scarcely been diminished by the passage of time, Warhol's Disasters have gathered expressive force, seen apart from his movie stars and the comic-strip heroes of Roy Lichtenstein or Claes Oldenburg's giant hamburgers.

Bacon's probing portraits, however, could not be farther from the sleek, glamorized likenesses created by Warhol. One of Bacon's most poignant images, *Portrait of George Dyer Crouching* (1966), 50 is at once a portrait of a friend and a pathetic image of modern man. "In trying to paint a portrait I would like it to be a likeness—I would like it to be a universal image as well as a specific fact."[68] While the pose and format are taken from Bacon's *Study for 28 Crouching Nude* (1952), which in turn was derived from Muybridge, the ambiguous structure that encircles Dyer recalls the tubs of Degas's bathing women. Dyer is inexplicably perched at the edge of what might be a coffee table, as though poised on the

48. *Study for Self-Portrait*, 1963
Oil on canvas, 65 x 57 in.
National Museum of Wales, Cardiff

49. George Dyer. Photograph by John Deakin

See pages 46, 47:

50. *Portrait of George Dyer Crouching*, 1966
Oil on canvas, 78 x 58 in.
Private collection, Caracas

51. *Portrait of George Dyer Staring at a Blind Cord*, 1966
Oil on canvas, 78 x 58 in.
Collection Maestri, Parma

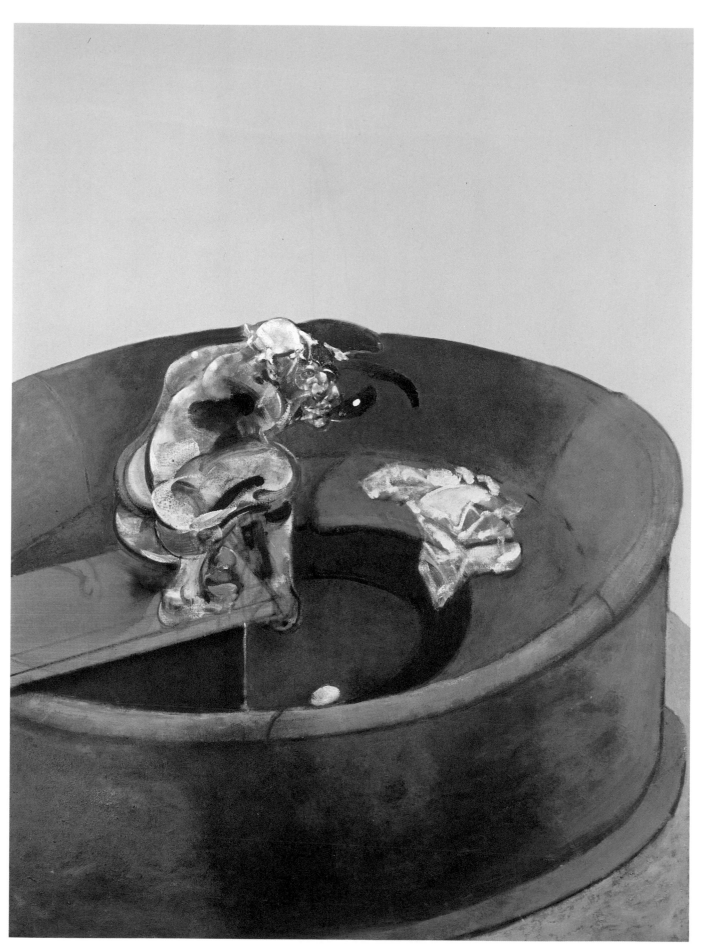

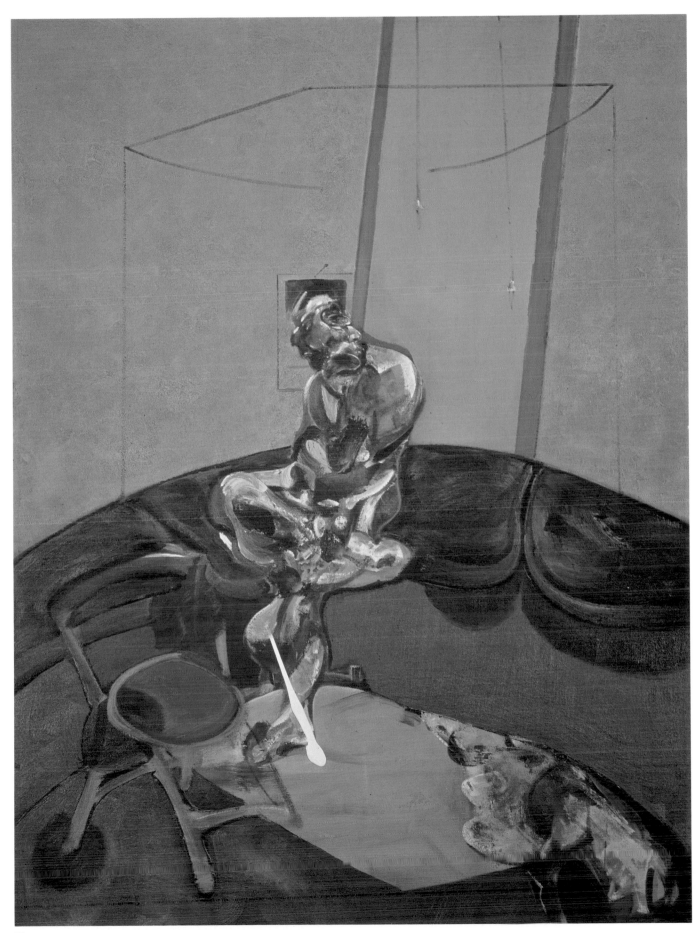

end of a diving board. His clothes tossed aside, the nude figure wears on his head the knotted handkerchief conventionally if incongruously worn on sunny days by English men at beaches and sporting events. Green and black protuberances give Dyer's face a peculiarly reptilian character. Like some bird pitifully stripped of its feathers, the squatting figure leans over an egglike form. A flurry of painterly marks depicts Dyer in profile as well as full face, his right eye compellingly direct as it confronts us.

51 In *Portrait of George Dyer Staring at a Blind Cord* of 1966 a similar Cubistic merging of profile and frontal views is used, suggesting the restless shifting of the figure. The robust flesh tones of the *Portrait of George Dyer Crouching* have drained away here, leaving a pallid figure punctuated by an impulsively hurled line of white pigment and framed by a faint linear cube. Dyer's face is similarly isolated by a rectangle illusionistically affixed to the wall by a long nail. This nail conspires with the wavering distortions of features and body to recall Michelangelo's self-portrait as the flayed Saint Bartholomew in the Sistine Chapel.

52 Two years later, in *Two Studies for a Portrait of George Dyer* (1968), a painted nude image of Dyer is "nailed" to a wall or canvas behind a clothed, seated figure of Dyer. The nails seem at once to affix a flat image to a wall, to wound the figure, and to invoke the illusionistic nails introduced by Braque into a number of still lifes around 1910. An impetuously flung streak of white paint slides down Dyer's leg, as a similarly hurled handful of white paint had done in the 1966 portrait. From the mid-1960s on, Bacon has enlisted the element of chance afforded by such spontaneous application of pigment: "I can only hope that the throwing of the paint onto the already-made image or half-made image will either re-form the image or that I will be able to manipulate this paint further into—anyway, for me—a greater intensity."[69]

53 In *Portrait of George Dyer and Lucian Freud* of 1967, Dyer is more expansive, wearing the jacket, shirt, and tie that become familiar in Bacon's paintings of him.[70] Sitting in front of heavy green curtains recalling those in Bacon's studio, Dyer presides with panache—face turning theatrically from side to side—over this encounter with Freud, whose anatomy twists inward in a self-contained posture.

 The subject of Bacon's first identified portrait, done in 1951, this painter and grandson of Sigmund Freud reappears in a full-
54 length portrait triptych, *Three Studies for a Portrait of Lucian Freud* (1969). Freud sits on a cane-bottomed chair like those in Bacon's studio, but the artist has also incorporated the headboard recorded in photographs of Freud sitting on a bed, a headboard that echoes the thrones of Bacon's popes. In each panel Freud's face is divided by a vertical element of the cube structure that surrounds him. A
55 similar bisection had obscured the face in the *Portrait of George Dyer in a Mirror* (1968), but here the features of Freud are elucidated, since the skewed cube seems to multiply our vantage point prismatically. The concealed face of Dyer in the 1968 portrait is visible only in the massive televisionlike mirror, its reflection broken in half as if the speed of Dyer's motion had eluded even the mirror's ability to record.

52. *Two Studies for a Portrait of George Dyer*, 1968
Oil on canvas, 78 x 58 in.
Sara Hilden Foundation, Sara Hilden Art Museum, Tampere, Finland

53. *Portrait of George Dyer and Lucian Freud*, 1967
Oil on canvas, 78 x 58 in.
Destroyed

54. *Three Studies for a Portrait of Lucian Freud*, 1969
Oil on canvas, triptych, each panel 78 x 58 in.
Private collection, Rome

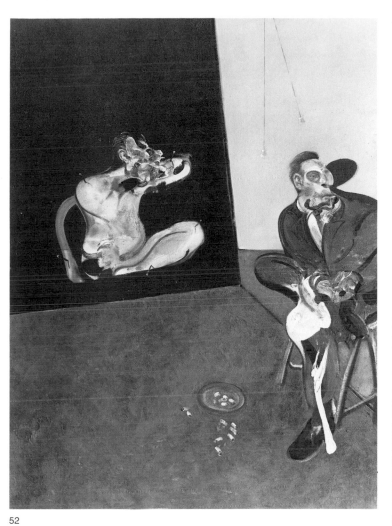

52

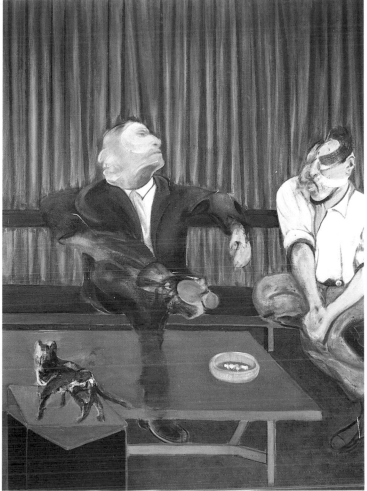

53

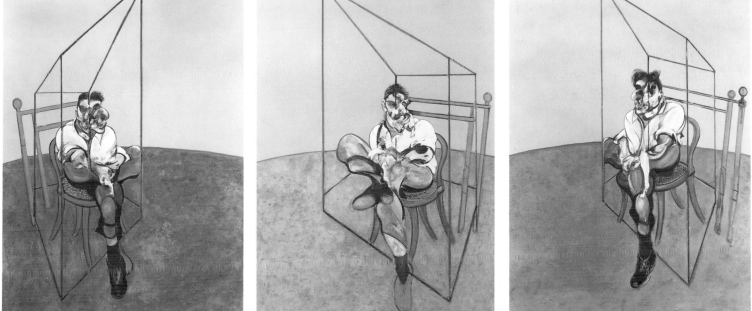

54

55

In the late 1960s Bacon increasingly incorporated multiple views of his portrait subjects within a single canvas. As though to outwit the imprecision of perception, the reworkings of memory, the reversals and fragmentations of mirrors, and the distortions of photographs, he reiterated and amplified the features, mannerisms, gestures, and postures of his subjects. Despite his belief that it is impossible ever to know someone completely—"Even when you're in love, you can't break down the barriers of the skin"—Bacon searched the surfaces of his friends for some intimation of their inner lives. "Any movement you paint has all kinds of other implications. Why and how a person stands or sits conveys all sorts of other things." Declaring that he is not religious and does not believe in the soul, Bacon concludes that mind, nervous system, and body are one.[71]

Bacon's attraction to Muybridge's studies of motion and to Maxwell's photographs of wild animals had suggested early on his interest in transcending the limitations of the static image. The smeared suggestion of mobility that had emerged in his work by the end of the 1950s anticipated the sweeping marks that would

55. *Portrait of George Dyer in a Mirror*, 1968
Oil on canvas, 78 x 58 in.
Thyssen-Bornemisza Collection, Lugano

56. *After Muybridge—Study of the Human Figure in Motion—Woman Emptying a Bowl of Water and Paralytic Child on All Fours*, 1965
Oil on canvas, 78 x 58 in.
Stedelijk Museum, Amsterdam

57. *Studies of George Dyer and Isabel Rawsthorne*, 1970
Oil on canvas, diptych, each panel 14 x 12 in.
Private collection

56

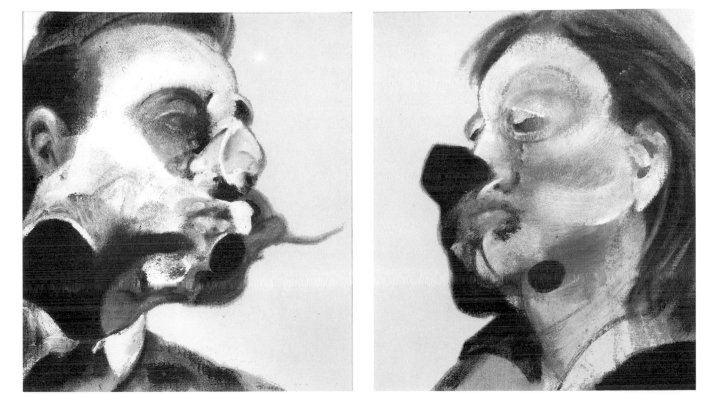

57

51

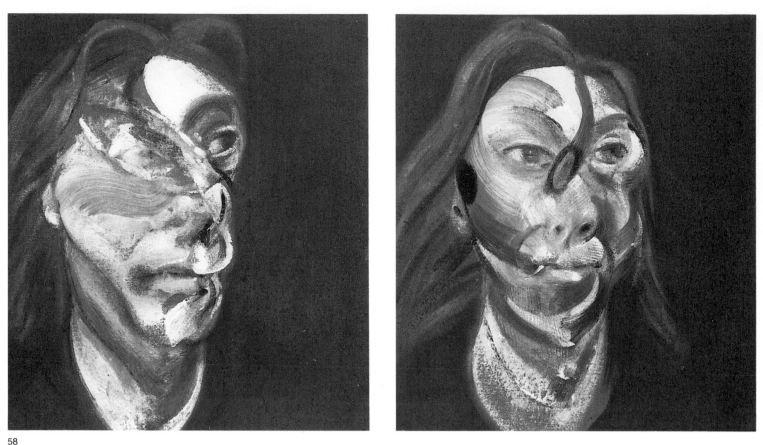

58

describe his subsequent figures in motion. His exploration of multiple views of a single subject might well be seen as extending the devices of Cubism, as Picasso had done in *Girl before a Mirror* of 1932, to probe the emotional complexity of his subjects. "Isn't it that one wants a thing to be as factual as possible and at the same time as deeply suggestive or deeply unlocking of areas of sensation other than simple illustration of the object that you set out to do?" Bacon has said. "A non-illustrational form works first upon sensation and then slowly leaks back into the fact. Now why this should be, we don't know. This may have to do with how facts themselves are ambiguous, how appearances are ambiguous, and therefore this way of recording form is nearer to the fact by its ambiguity of recording."[72]

Bacon again scrutinized the face of Dyer, this time along with that of their friend Isabel Rawsthorne, in a diptych of 1970. Scraped, blotted, and dragged strokes of transparent and opaque paint coalesce to conjure with startling veracity the appearances of Dyer and Rawsthorne. So tightly framed are these heads that we confront them from a vantage point more intimate than conventional propriety would permit. The flat pale lavender background complements the flesh tones of the figures, lending the portraits a delicacy that contrasts sharply with the tumultuous emergence of Rawsthorne's fiery visage from the black setting of *Three Studies for Head of Isabel Rawsthorne* (1965). The small triptych format of this portrait has proved an effective one for Bacon, the frontal and paired profile views "rather like police records."[73]

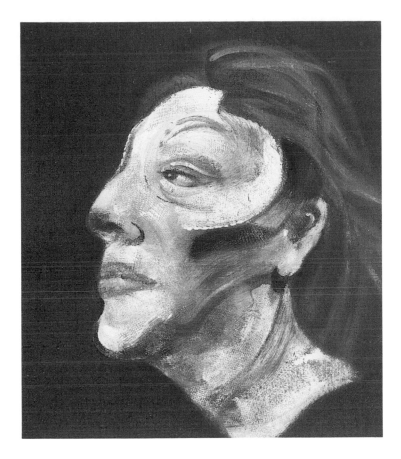

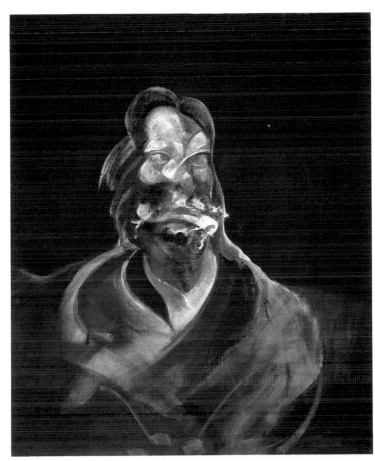

58. *Three Studies for Head of Isabel Rawsthorne*, 1965
Oil on canvas, triptych, each panel 14 x 12 in.
University of East Anglia, Norwich;
Robert and Lisa Sainsbury Collection

59. *Portrait of Isabel Rawsthorne*, 1966
Oil on canvas, 26¾ x 18⅛ in.
The Tate Gallery, London

59

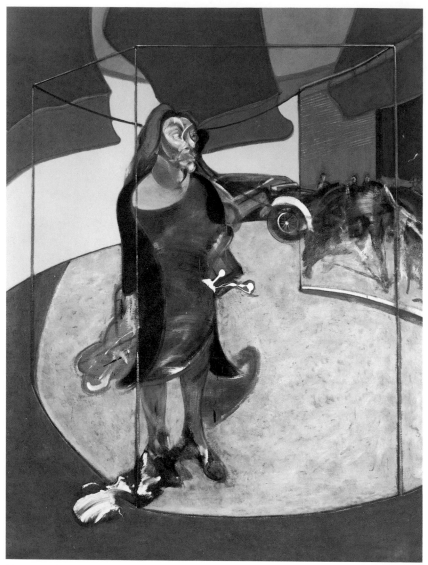

60

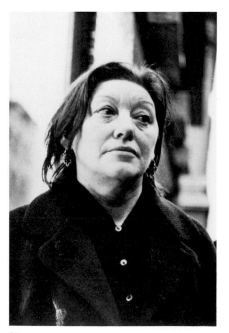

61

Bacon had focused on Isabel Rawsthorne in a number of previous paintings, including *Three Studies of Isabel Rawsthorne* and *Portrait of Isabel Rawsthorne Standing in a Street in Soho*, both of 1967. In *Three Studies* she reaches toward an abnormally high lock, key in hand, glancing over her shoulder as though to spot pursuers. In the darkness beyond the door, she appears a second time, wearing gold earrings and perhaps a black dress in this lightless place. Pinned to the wall at the left is a third image of Rawsthorne, its vertical striations mimicking the veiling of Bacon's figures during the 1950s and lining up with the stripes of the screen to which it is attached.

Except in the Crucifixions of 1962 and 1965, Bacon's figures had remained notoriously alone and unaware of the observer. Screaming popes and close friends alike emerge in his paintings without defenses, viewed in the privacy of familiar rooms, stripped of the contrivance of self-conscious posing. But the furtive, sideways glance of Isabel Rawsthorne as she grasps the key introduces the specter of an unseen figure—witness, pursuer, or intruder. In its implication of an observer, *Three Studies of Isabel Rawsthorne* is linked with *Triptych Inspired by T. S. Eliot's Poem "Sweeney Agonistes"* of the same year.

Spattered with blood, the Pullman car setting of the central panel of *"Sweeney Agonistes"* contains the gruesome evidence of a violent crime, perhaps in reference to a line uttered by Sweeney in Eliot's poem: "I knew a man once did a girl in."[74] The black window shade is pulled to reveal the night sky as a vibrant passage of blue. On the floor a valise lies open, its zipper glimmering like a row of teeth. The shallow space of this central canvas is echoed on either side in linear cubes that define the settings for pairs of figures whose feet are glimpsed in mirrors attached to the daislike platforms. The figures at left recline side by side in similar postures of relative repose, while those at right embrace or struggle, like the *Two Figures* (1953). In their mirror the reflected image is dominated by a man on the telephone, who is curiously unmoved by the activity before him. This figure was perhaps suggested by Eliot's Pereira, whose call intrudes on the conversation of Dusty and Doris in "Sweeney Agonistes."[75] In its imagery of struggle, copulation, repose, and death, the triptych echoes Sweeney: "Birth, and copulation, and death./ That's all the facts when you come to brass tacks:/ Birth, and copulation, and death."[76] The apparent blindness of the witness to the drama being played out before him speaks of the ultimate solitariness of human experience. The enigmatic relationship of the figures, and of the three panels themselves, reflects Bacon's interest in avoiding narrative continuities.

The moment there are several figures—at any rate several figures on the same canvas—the story begins to be elaborated. And the moment the story is elaborated, the boredom sets in; the story talks louder than the paint. . . . I don't want to avoid telling a story, but I want very, very much to do the thing that Valéry said—to give the sensation without the boredom of its conveyance. And the moment the story enters, the boredom comes upon you.[77]

62
60
63
36

60. *Portrait of Isabel Rawsthorne Standing in a Street in Soho*, 1967
Oil on canvas, 78 x 58 in.
Staatliche Museen Preussischer Kulturbesitz, Nationalgalerie, West Berlin

61. Isabel Rawsthorne.
Photograph by John Deakin

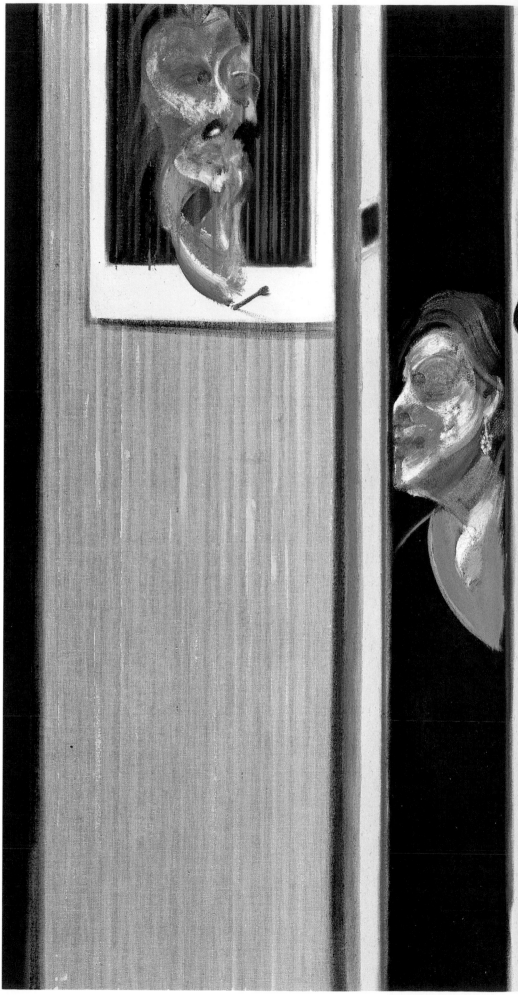

62. *Three Studies of Isabel Rawsthorne*, 1967
Oil on canvas, 47 x 60 in.
Staatliche Museen Preussischer Kulturbesitz,
Nationalgalerie, West Berlin

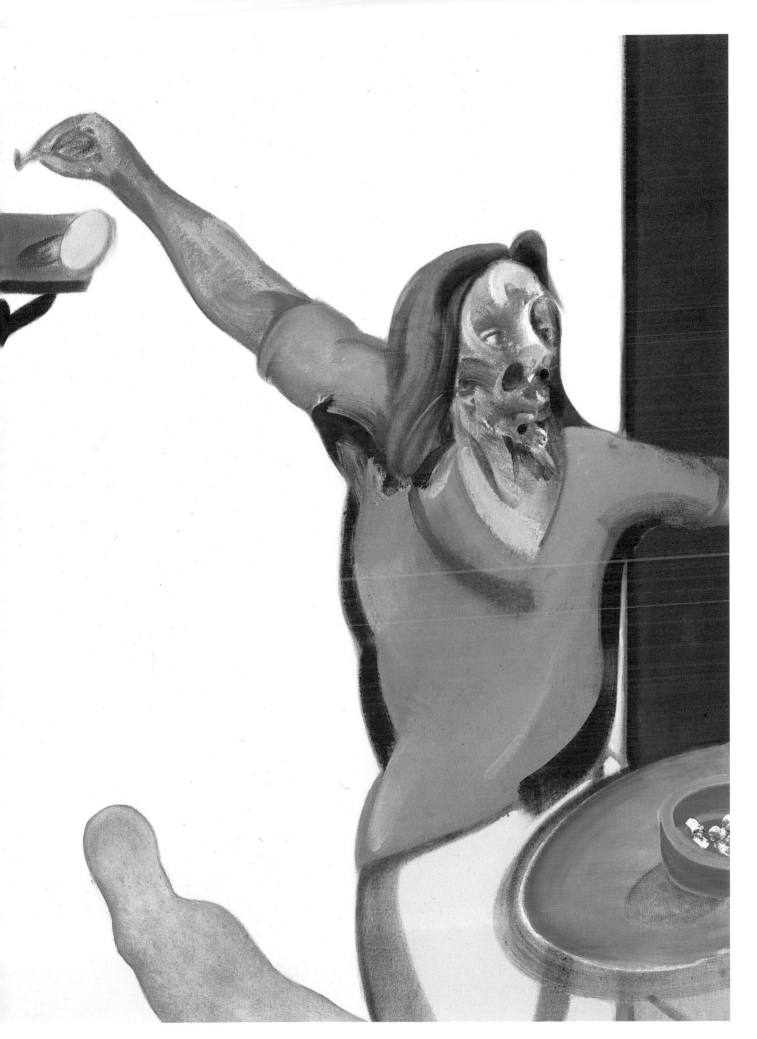

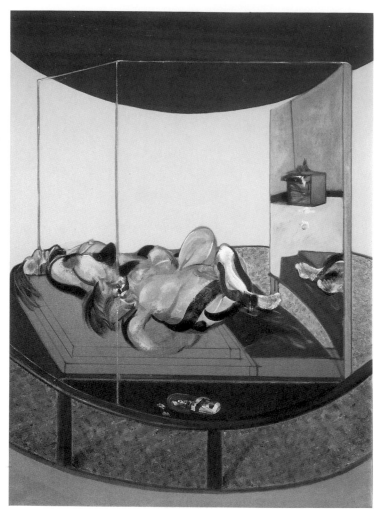

63

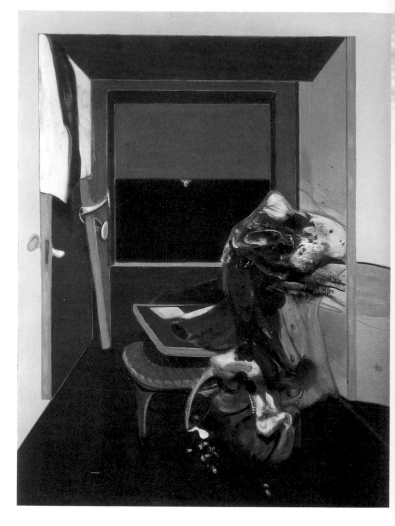

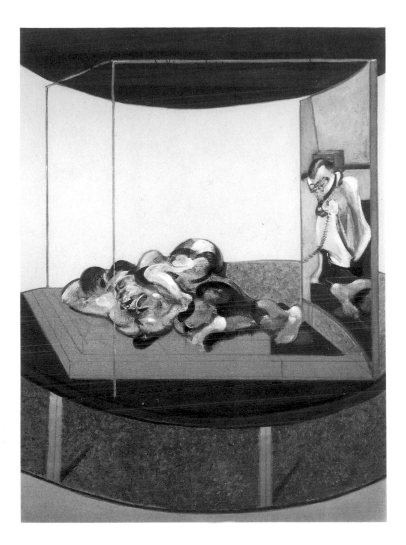

63. *Triptych Inspired by T. S. Eliot's Poem "Sweeney Agonistes,"* 1967
Oil and pastel on canvas, triptych, each panel
78 x 58 in.
Hirshhorn Museum and Sculpture Garden,
Smithsonian Institution, Washington, D.C.

Bacon explored a variety of spatial treatments in his triptychs of the 1960s. While the rounded settings of the three panels of *Crucifixion* (1962) are similar, their relationship to each other remains unclear. A more pronounced ambiguity derives from the alternation of architecturally unrelated spaces in *"Sweeney Agonistes"* of 1967. While the rooms shown at right and left are almost identical, they are separated by the jarringly dissimilar sleeping compartment of the central panel. In both *Crucifixion* (1965) and *Two Figures Lying on a Bed with Attendants* (1968) the space is essentially continuous, spanning the frames that divide the horizontal panorama into a trio of vertical paintings.

Nestled together in parallel poses, the privacy of their room guarded by Venetian blinds closed on the daylight beyond, the central subjects of *Two Figures Lying on a Bed with Attendants* are striking in their stillness and closure. But they are not alone, instead flanked by pendant figures, one nude, one clothed. This insinuation of voyeurs into the bedroom assumes a more conventional guise in *Study of Nude with Figure in a Mirror* (1969). The reclining nude woman was probably based on photographs of Henrietta Moraes, the subject of several other portraits of

59

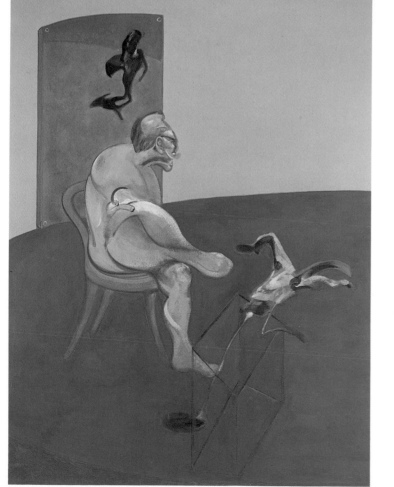
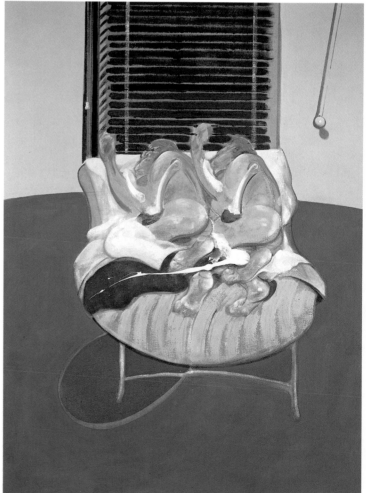

64. *Two Figures Lying on a Bed with Attendants*, 1968
Oil and pastel on canvas, triptych, each panel 78 x 58 in.
Present location unknown

65. *Study of Nude with Figure in a Mirror*, 1969
Oil on canvas, 78 x 58 in.
Private collection

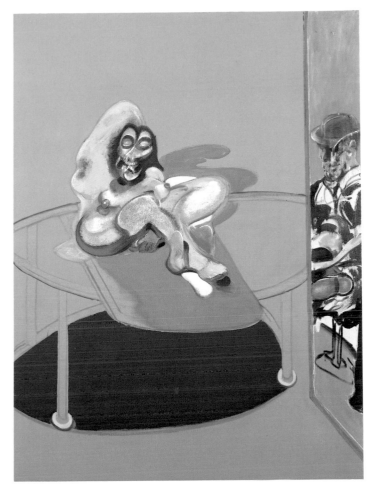

65

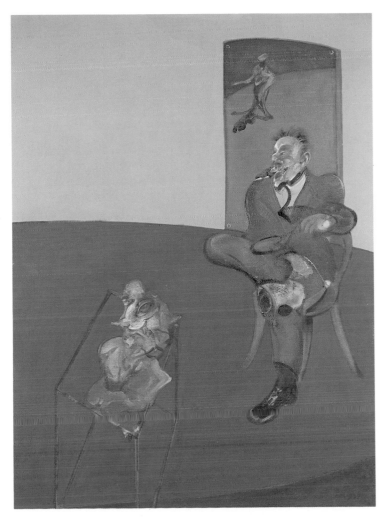

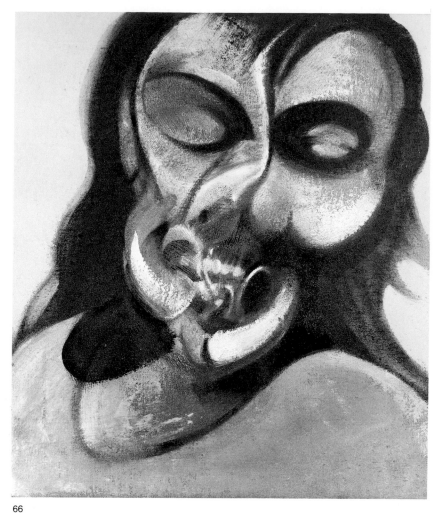

66

66. *Study of Henrietta Moraes*, 1969
Oil on canvas, 14 x 12 in.
Private collection, Johannesburg

67. *Study for Bullfight No. 1*, 1969
Oil on canvas, 78 x 58 in.
Private collection

this year.[78] The smiling man viewed in the mirror recalls the well-to-do "suitors" glimpsed backstage in Edgar Degas's images of dancers and the patrons of brothels in the works of Henri de Toulouse-Lautrec.

The mirror is a stealthy, impartial intruder, and the voyeur is himself exposed to our unexpected observation. The watchful figures in *"Sweeney Agonistes"* and *Nude with Figure in a Mirror* would seem to come from the viewer's own space, reflected as they are in mirrors that search beyond the hermetic realms of the reclining and embracing nudes. As in Manet's *Bar at the Folies-Bergère* (1881–82), we too are implicated, side by side with the painter.

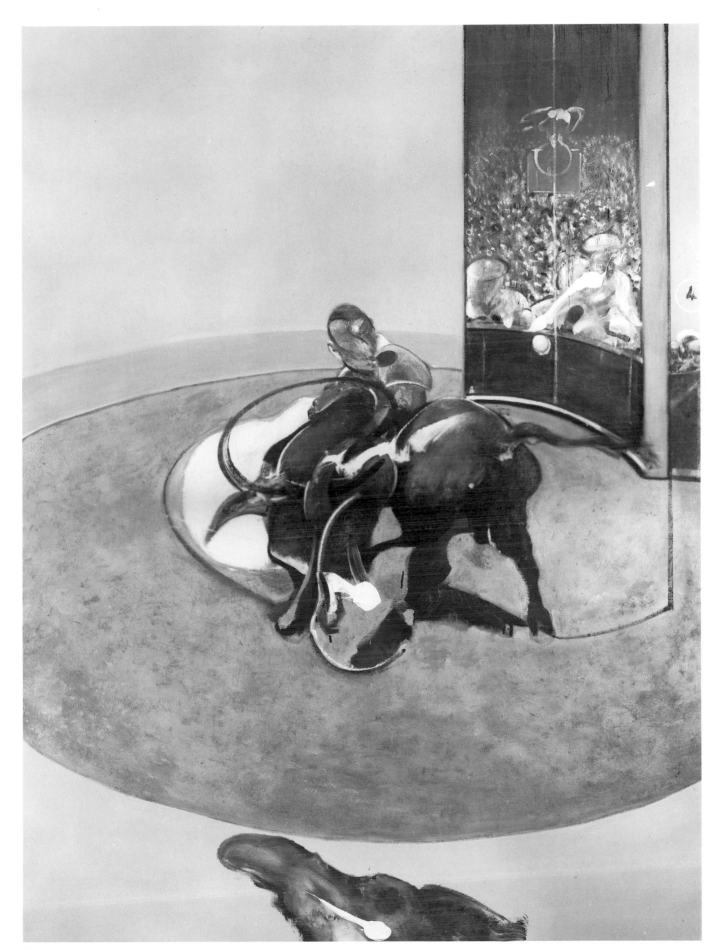

67

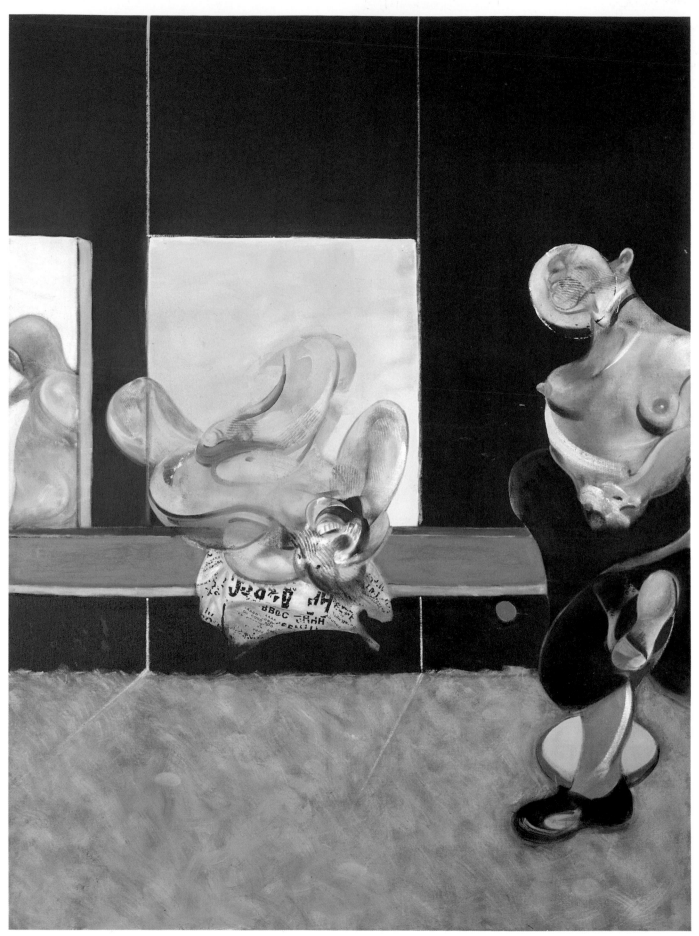

3 Images of Mortality

The interlocked figures introduced in 1953 were painted repeatedly by Bacon in the 1970s, in some cases taking on the frenzied momentum of a struggle against death. The work of the decade reflects his own confrontation with mortality and reveals a process of taking stock, as he considered his role as artist-observer. It was a time for recollection—of recent events and of imagery stretching back into the 1940s. This retrospection was prompted in part by the major exhibition of Bacon's work of four decades, which opened in October 1971 at the Grand Palais in Paris. But the acute sense of life's fragility that pervades the paintings of the 1970s was sharpened by the death of George Dyer that year in Paris. Bacon mused two years later: "The hardest thing about aging is losing your friends. My life is almost over and all the people I've loved are dead."[79] The shadows of this decade take on the colors of darkness and of flesh, as though palpable evidence of Bacon's sense of human vulnerability. "But then, perhaps, I have a feeling of mortality all the time. . . . I'm always surprised when I wake up in the morning."[80]

Bacon confronted Dyer's death in works painted over several years. In format and complex imagery, *Triptych* (1971), *Three Portraits—Triptych, Posthumous Portrait of George Dyer, Self-Portrait, Portrait of Lucian Freud* (1973), and the first two "black triptychs" (1972 and 1973) link portraiture with Bacon's more broadly allusive triptychs. For while Dyer, Bacon, and Lucian Freud are readily recognizable in this succession of paintings, the larger associational context permitted by the triptych format also casts them as protagonists in a fitful and ill-fated drama.

In a somber transformation of the wrestling nudes seen in so many images of the 1970s, George Dyer looks like a toppled boxer struggling with an unseen opponent in the left panel of *Triptych* (1971). In the central panel, illuminated by the yellow glare of a bare bulb, a spectral figure of Dyer turns a key in a door. The space is skewed, Caligari-like, as though seen through the eyes of the distraught Dyer as he gazes back toward the stairs and the window through which the night sky is seen. In the right panel his image is silhouetted as a portrait bust before a tombstonelike block and mirrored, in reverse, in the reflective surface of a café table.

69, 73

70, 75

69

68. *Studies from the Human Body*, 1975
Oil on canvas, 78 x 58 in.
Gilbert de Botton, Switzerland

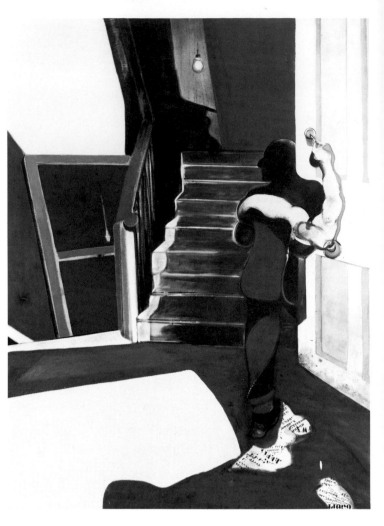

69

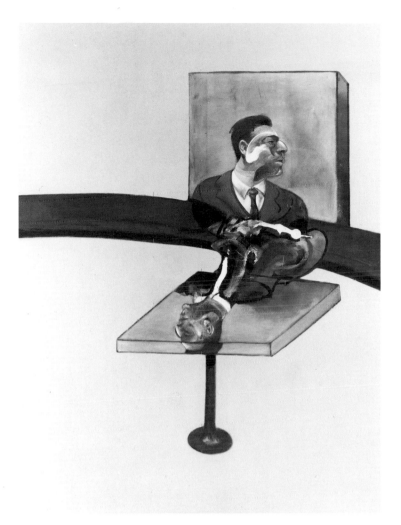

69. *Triptych*, 1971
Oil on canvas, triptych, each panel 78 x 58 in.
Private collection, United States

The painting of "real" and mirror images recalls the lively, restless Dyer in the *Portrait* of 1968. It is as though the disintegration of the figure in death is banished as memory grapples to restore its wholeness. Asked in 1966 if he were saying that "painting is almost a way of bringing somebody back, . . . [if] the process of painting is almost like the process of recalling," Bacon replied, "I am saying it."[81]

The doorway—at once alluring and ominous in *Triptych* (1971)—figures crucially in the black triptychs. Walls parallel to the picture plane define the shallow settings of the three paintings, the steep foreground space thrusting the subjects toward the viewer. The rectilinearity and the monochrome color of the doorways serve as foils to the biomorphic forms of bodies and shadows. The tragedy of Dyer's death is recorded within this simple, rhythmic architectural context.

In the first of the black triptychs, *Triptych, August* (1972), a pair of figures wrestle perilously near the void of the doorway, the image of embrace transformed into a metaphor of mortal combat. The left and right panels each contain a seated figure facing to the right: the man at left is Dyer, the one at right resembles Bacon.

67

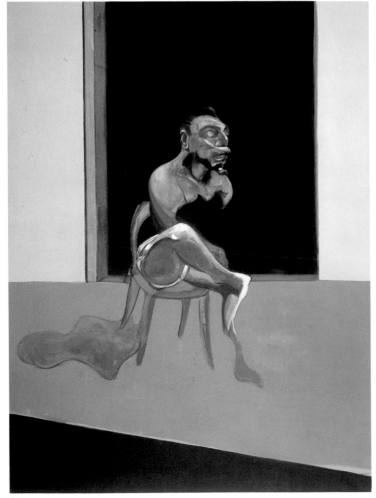

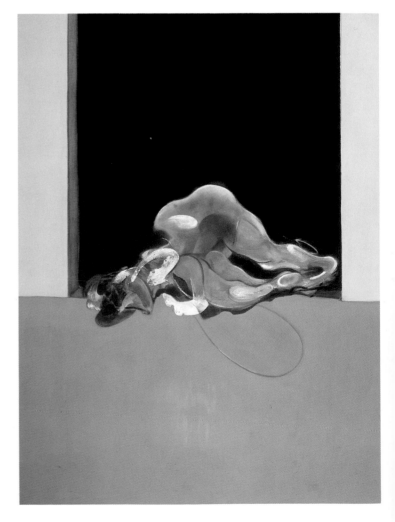

While Dyer faces the combat with eyes closed and face still, the figure at right faces away from his companions in the adjacent panels. Life seems visibly to drain from both figures into the oddly substantial, flesh-colored shadows beneath them. The curiously sumptuous character of the pink and cobalt violet shadows, complementing the livid hues of the figures, calls to mind Monet's chagrined observation that "colour is my day-long obsession, joy and torment. To such an extent indeed that one day, finding myself at the death-bed of a woman who had been and still was very dear to me, I caught myself in the act of focusing on her temples and automatically analysing the succession of appropriately graded colours which death was imposing on her motionless face."[82] In the dissolution of their anatomies these figures echo Michelangelo's *Captives* of 1527–28, struggling to emerge from the marble blocks in which they are entrapped.

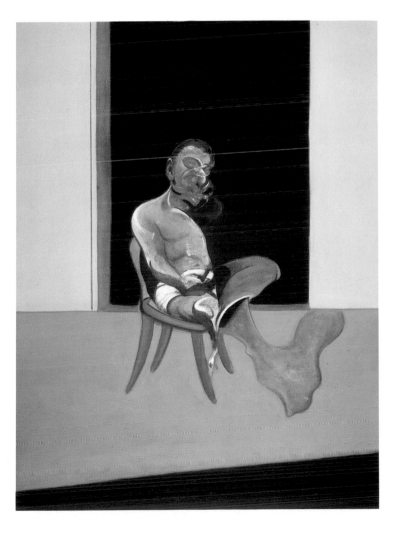

71

73 Bacon is flanked by his closest friends in *Three Portraits—
Triptych, Posthumous Portrait of George Dyer, Self-Portrait, Por-
trait of Lucian Freud*. A smear of paint pulled to the right of his
head balances the hand to the left, with the two elements functioning
like blinders to ward off the stares of his neighbors. "Pinned" to
71 the wall are two "photographs": behind Dyer, at left, an image of
72 Bacon, and behind Freud, at right, a photo of Dyer. This incorpora-
tion of illusionistically rendered black and white photographs may
be an acknowledgment of photography's memory-triggering role
in Bacon's work and underlines the disparities between the fixity
of photography, the flexibility of painting, and the subjectivity
of perception and memory.

71. Detail of plate 73

72. Detail of plate 73

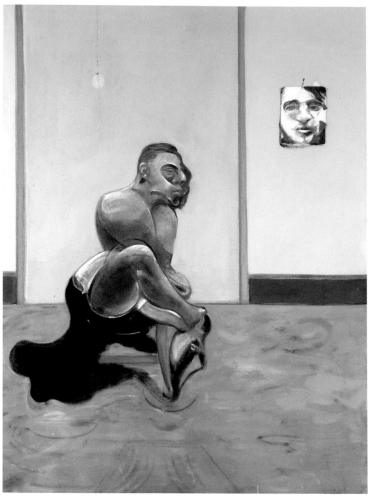

73

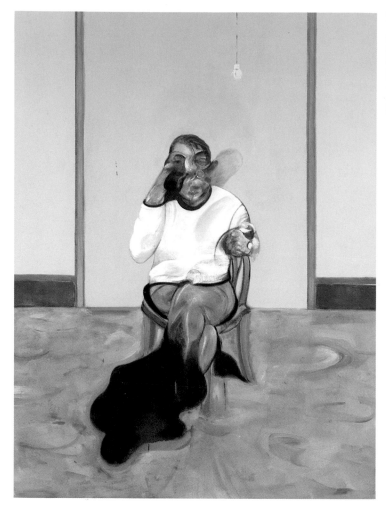

73. *Three Portraits—Triptych, Posthumous Portrait of George Dyer, Self-Portrait, Portrait of Lucian Freud*, 1973
Oil on canvas, triptych, each panel 78 x 58 in.
Private collection

74. Detail of plate 73

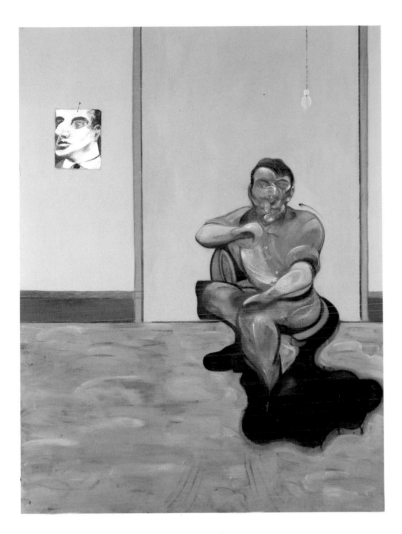

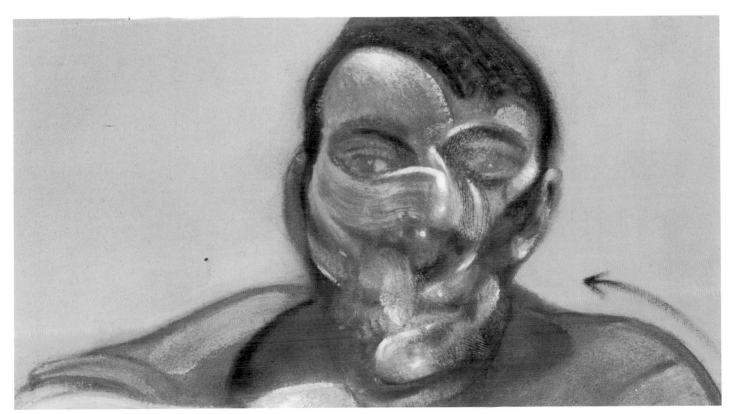

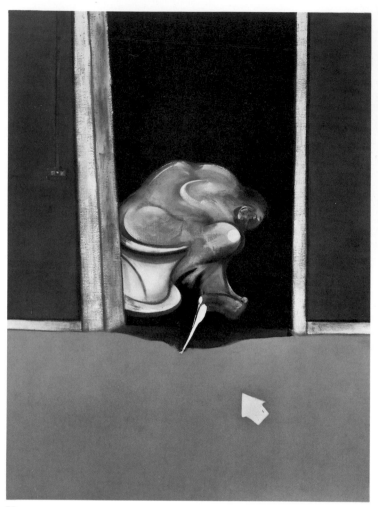

75

The bare bulbs suspended over each of the figures can scarcely account for the black shadows that disturb the painting. The bad omen of these dark counterparts of the figures is fulfilled in the second black triptych, *Triptych, May–June* (1973). The setting suggests instability, with the doorways of the side panels splayed outward and darkness seeping into the foreground. A batlike shadow looms in the central panel, as though the illogical product of the bulb swinging wantonly above the figure, and seems to be some grim messenger of death.

The space in *Triptych, August* and in *Three Portraits—Triptych, Posthumous Portrait of George Dyer, Self-Portrait, Portrait of Lucian Freud* might be read either as a panoramic view of a single wall containing three doorways or as successive views of a single space containing different figures and viewed from slightly different angles. In *Triptych, May–June*, Bacon shows sequential views of a single figure, like stills from a film. He has reversed the conventional left-right progression and has, again as in a film, aban-

75. *Triptych, May–June*, 1973
Oil on canvas, triptych, each panel 78 x 58 in.
Mr. and Mrs. Saul P. Steinberg, New York

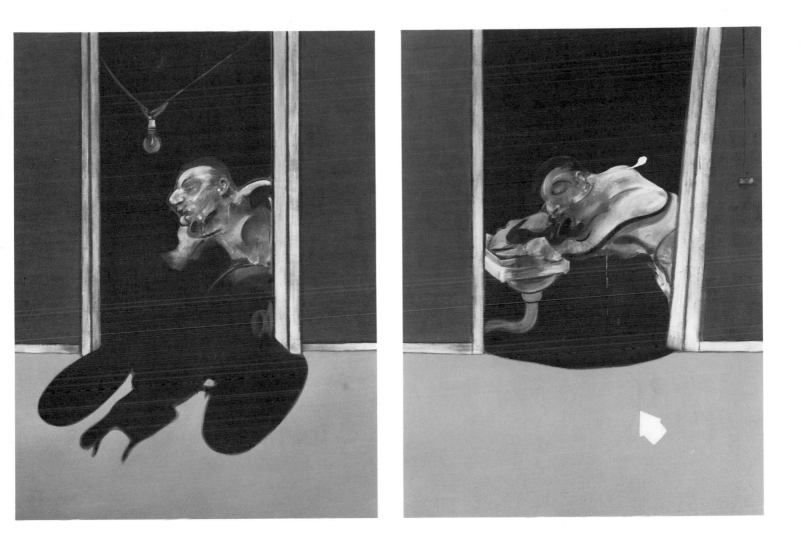

doned a fixed viewpoint. We look through one doorway in the left panel and through another in the center and right panels. Read from right to left, the images depict the facts of Dyer's death, as the nude figure vomits into the bathroom sink, crosses the room, then dies on the toilet. The sinuous, agonized curves of Dyer's arm and shoulder at right are continued by the curve of the sink's drainpipe. The pitiful, almost fetally positioned figure at left has a closed composure in opposition to the distended agony of the adjacent panels. The white arrows in the foreground of the side panels were added to counter the sensational character of the subject matter by inserting a note of clinical objectivity. [83]

Viewed chronologically, *Triptych* (1971) and the first two black triptychs consider with mounting directness their theme of loss. While in the painting of 1971 the figure struggles in solitude and approaches the doorway with key in hand, it is only in the image of May–June 1973 that, literally and metaphorically, he crosses the threshold, beyond reach.

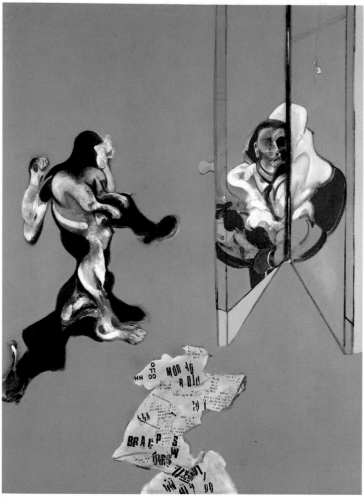

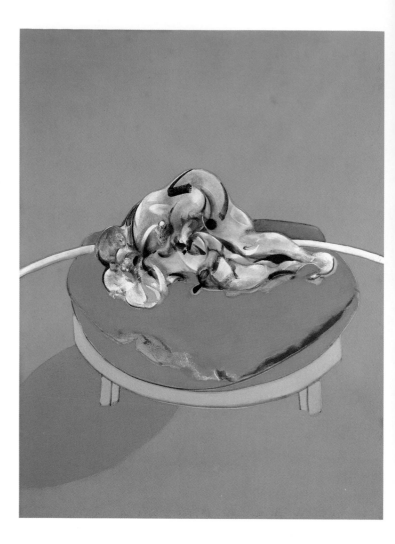

76

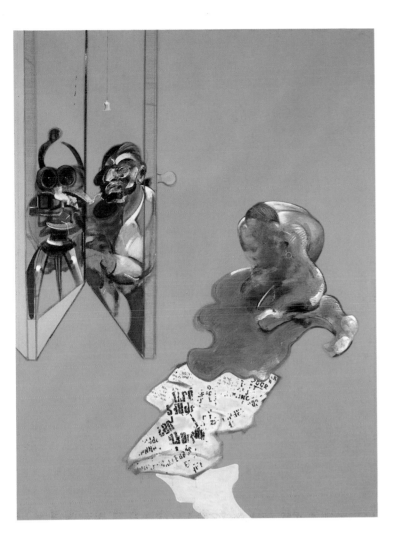

76. *Studies from the Human Body,* 1970
Oil on canvas, triptych, each panel 78 x 58 in.
Jacques Hachuel

If in *Triptych, August* and *Three Portraits—Triptych, Posthumous Portrait of George Dyer, Self-Portrait, Portrait of Lucian Freud,* Bacon recoiled from the faces of his friends, he had earlier appeared in *Studies from the Human Body* (1970) as an observer 76 shielded partially by the curiously animate camera—its eyes agape, horns upright. He is watched by us as he watches the central nude figures, who are visually skewered by the railing encircling them. The artist's reflection in the right panel invokes Velázquez's self-portrait in *Las Meninas,* which Bacon considers "among the greatest paintings ever made."[84] The unmodulated fields of bright color against which the figures are seen and the neutral, undetailed spaces in which the action unfolds typify the settings of Bacon's paintings from about 1960 onward. "I hate a homely atmosphere. . . . I would like the intimacy of the image against a very stark background. I want to isolate the image and take it away from the interior and the home."[85]

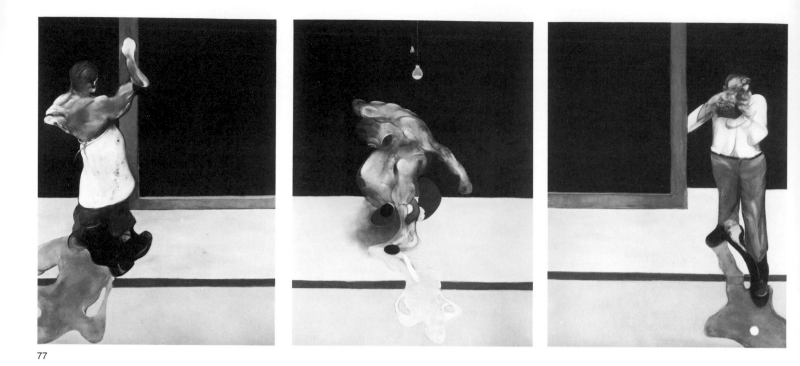

77

Another cameraman, not Bacon, enters through a darkened door-
77 way into the rectilinear space of *Triptych, March* (1974), the final
work of the black trilogy. Face and camera merge as they turn
their sights toward us. In the left panel a butcher described with
Daumieresque suppleness turns away from us toward a blackened
wall and doorway, which mirror the architecture of the camera-
man's space. Like an update of Myron's *Discus Thrower* of the
fifth century B.C., a figure twists athletically in the central panel,
an image of musculature and contrapposto that is timeless save for
the bare light bulb suspended above.

In its juxtaposition of a classical image of human movement, a
butcher, and an observer-recorder-cameraman, the painting toys
with and inverts themes that have concerned Bacon throughout his
career. The often ungainly postures captured by Muybridge and
transformed by Bacon are here replaced by an ideally graceful
athlete. In place of the carcass, we encounter the butcher; instead
of the cinematic subject, we discover the cameraman. As victim
gives way to active protagonist, *Triptych, March* transcends the
pathos of its companion triptychs to become an enigmatic and
summary work.

The tenuousness of life is underscored in Bacon's repeated sug-
gestion of the fragility of the human body. In no painting is this
78 more cloquently expressed than in *Study for Portrait (Michel Leiris)*
(1978). The skull-like depiction of Leiris's cranium at right, the
broken white line that links Leiris's nose and ear, and the black
ground against which the head is viewed offer compelling evidence
that as Bacon considered the face of his friend, he remembered as
well the photographs and X-ray images of K. C. Clark's book
83 *Positioning in Radiography* (1929), which had long intrigued him.

In this portrait, hinting as it does at the anatomy of bone beneath the flesh, Bacon embodies Leiris's observation that "all flesh is eroded by its future absence" and recalls Cocteau's remark: "Each day in the mirror I watch death at work."[86]

Bacon had anticipated the juxtaposition of the voluptuous flesh of the body with its more enduring if lifeless skeleton in *Three Figures and Portrait* (1975). The backbone of the figure at left protrudes, elucidated like the spinal column of Giacometti's *Palace at 4 a.m.* Circles, like lenses or the radiographer's targets indicated in Clark's book, lend focus to the figures, the slight distortion of George Dyer's face at left echoing the blurring created by the curve of optical glass.[87] The similar exposure of the spine in *Figure Writing Reflected in a Mirror* (1976) reflects the impact of Edgar Degas's *After the Bath* (1903). "You must know the beautiful Degas pastel in the National Gallery of a woman sponging her back. And you will find at the very top of the spine that the spine almost comes out of the skin altogether. And this gives it such a grip and a twist that you're more conscious of the vulnerability of the rest of the body than if he had drawn the spine naturally up to the neck. . . . In my case, these things have certainly been influenced by X-ray photographs."[88]

79

80

77. *Triptych, March*, 1974
Oil on canvas, triptych, each panel 78 x 58 in.
Private collection, Madrid

78. *Study for Portrait (Michel Leiris)*, 1978
Oil on canvas, 14 x 12 in.
Louise and Michel Leiris Collection, Paris

See pages 80, 81:

79. *Three Figures and Portrait*, 1975
Oil and pastel on canvas, 78 x 58 in.
The Tate Gallery, London

80. *Figure Writing Reflected in a Mirror*, 1976
Oil on canvas, 78 x 58 in.
Private collection

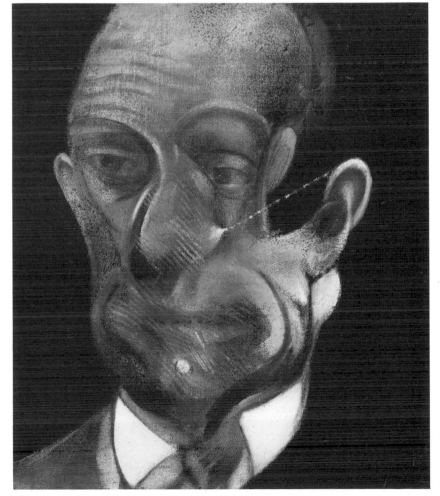

78

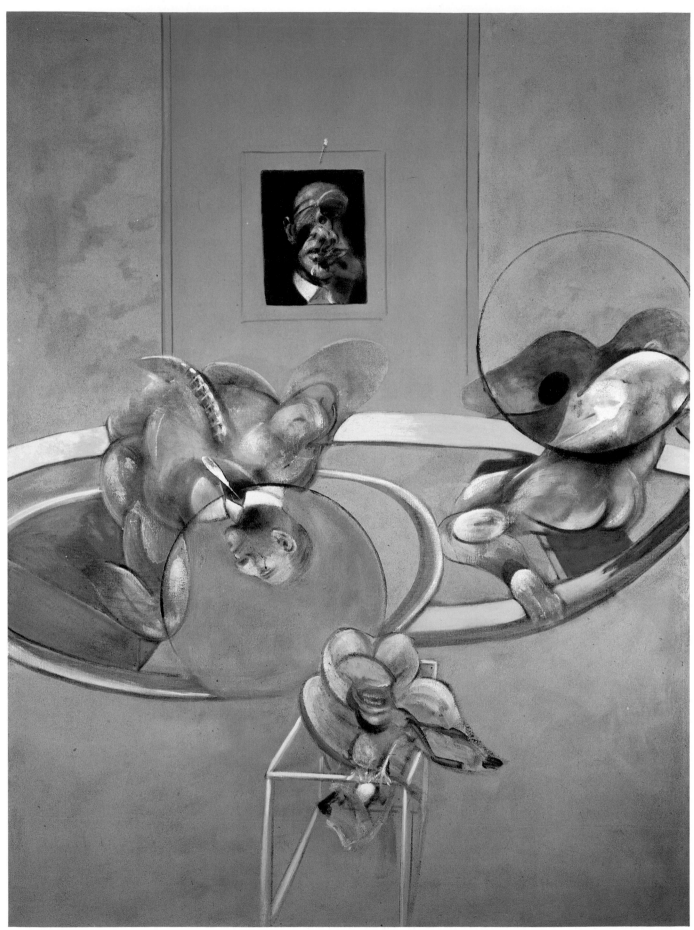

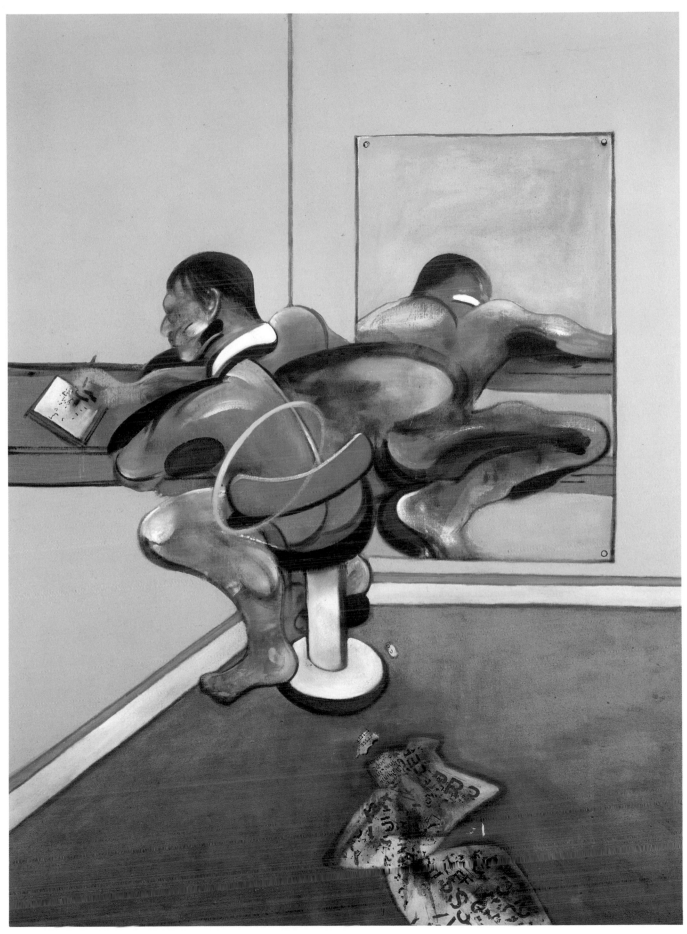

81. *Three Studies of Figures on Beds*, 1972
Oil and pastel on canvas, triptych, each panel
78 x 58 in.
Private collection

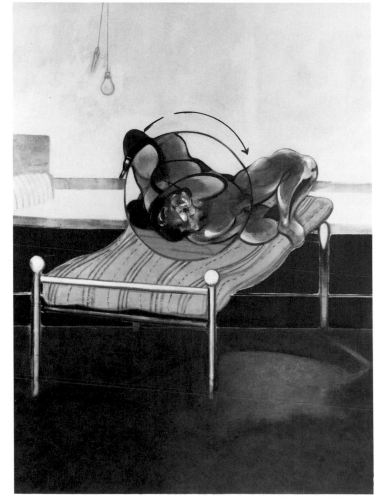

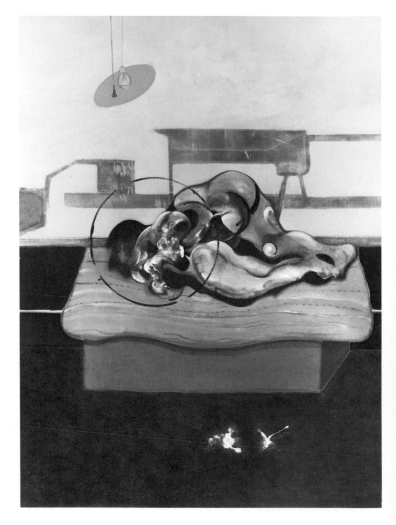

Trapped in our all too frail bodies, unable to "break down the barriers of the skin," we live shadowed by the inevitability of oblivion, our actions at once charged and undermined by that finality. The intertwined figures of Bacon's paintings embrace or struggle within the confines of this predicament. In the central panel of *Three Studies of Figures on Beds* (1972) the paired nudes appear in a Duchampian scenario. The churning rotary motion suggested by the circles and arrows surrounding the figures of all three panels recalls the halting movement of the waterwheel and chocolate grinder in Duchamp's pivotal image of frustrated, mechanical love, *The Bride Stripped Bare by Her Bachelors, Even* (*The Large Glass*) of 1915–23. Bacon admires Duchamp and has returned often to the text of a 1958 lecture in which Duchamp discussed the role of the unconscious in creativity: "All his decisions in the artistic execution of the work rest with pure intuition and cannot be translated into a self-analysis. . . . In the creative act, the artist goes from intention to realization through a chain of totally subjective reactions."[89]

81

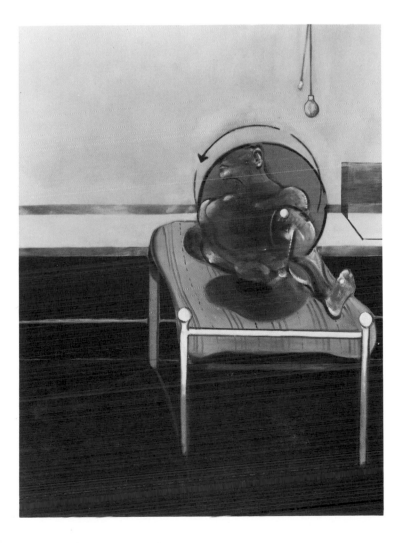

82 In *Triptych—Studies of the Human Body* (1979) the nudes in the central canvas are flanked by two male figures derived from the nude figures of Day and Twilight that face each other on the tombs of Giuliano and Lorenzo de' Medici in Michelangelo's Medici Chapel of 1519–34. A gash mars the back of the lefthand figure in Bacon's painting, the one related to Michelangelo's Day, as if to render human the marblelike flesh. In the central image, one figure's toothy mouth is mimicked by the broken line tangent to a knee at

83 right. This staccato linear element was probably inspired by photographs in *Positioning in Radiography*. The illustrations in Clark's book also contain circles, like those surrounding the knee and face in this panel, as well as letters and numbers recalled by Bacon's use of Letraset print. But most important, this manual of proper positioning for X rays shows its subjects in ungainly supine postures, heads unnaturally twisted, like those found here and elsewhere in Bacon's work.

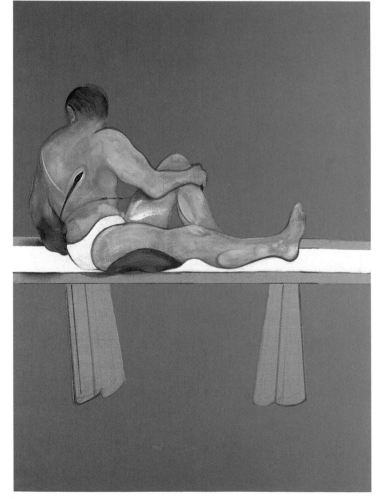

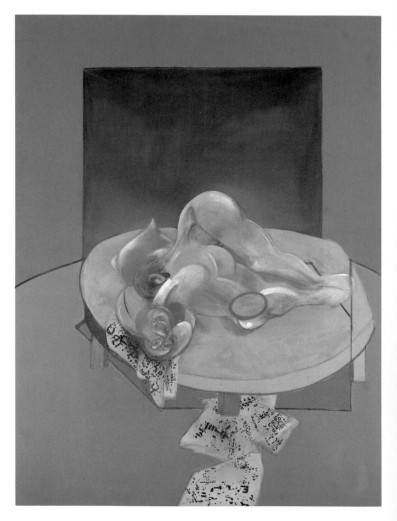

82. *Triptych—Studies of the Human Body*,
1979
Oil on canvas, triptych, each panel 78 x 58 in.
Private collection

83. Photographs from K. C. Clark's book
Positioning in Radiography, 1929

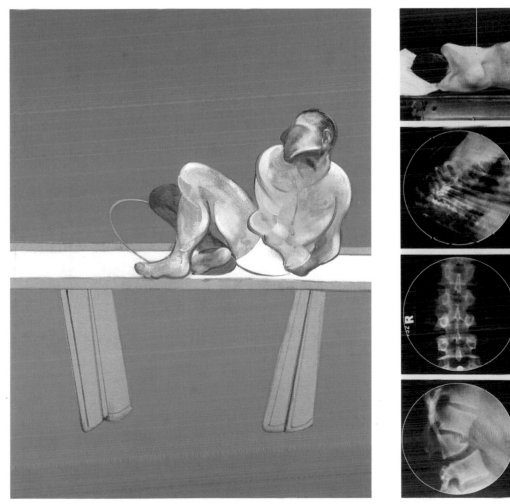

83

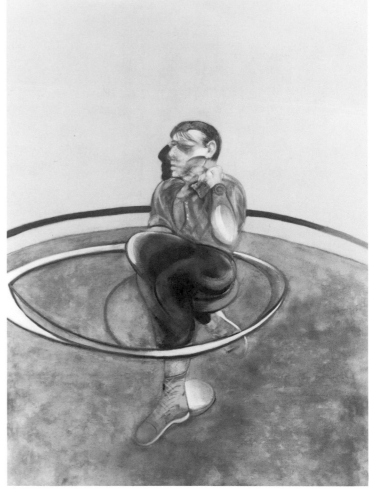

84

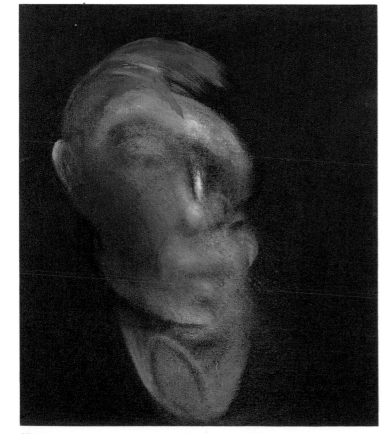

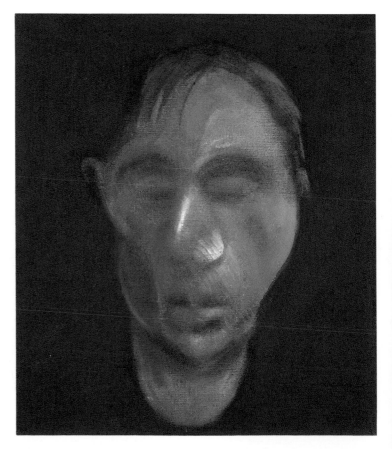

The inclusion in his imagery of photographer and photograph, the recollections of X-ray views, and the allusions to the seemingly voluptuous but in fact obdurately stone nudes of Michelangelo suggest Bacon's involvement with the issue of what he calls "appearance" and "fact." From *Studies from the Human Body* (1970) through *Triptych—Studies of the Human Body* (1979) the coupled figures of the decade are being watched—by Bacon the cameraman and his companion to the left in the earlier painting, by the figure at right in the later painting. Only in *Triptych, August* (1972) does the blackness of subject matter repel any witnesses. An averted glance, an opened mouth, the gesture of an arm or leg—all emerge from the flux of human activity, their momentary appearance noted and interpreted by their observer. For appearance is elusive: "It needs a sort of moment of magic to coagulate colour and form so that it gets the equivalent of appearance, the appearance that you see at any moment, because so-called appearance is only riveted for one moment as that appearance."[90]

During the past fifteen years Bacon has painted more than twenty self-portraits—"I've done self-portraits because I've had nobody else to do."[91] The shrillness with which he described the exit from life in the black triptychs eased somewhat in his self-portraits and portraits of the next few years. In *Self-Portrait* (1978) Bacon appears jaunty, dressed more colorfully than in any previous self-portrait, his delicately painted face lent emphasis by a luminous shadow that reitcrates his profile in silhouette. By the start of the next decade the sense of sadness that had dominated the work of the

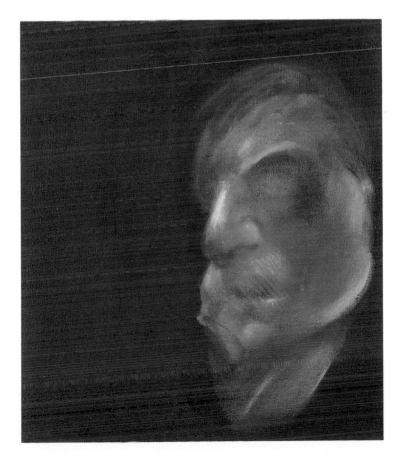

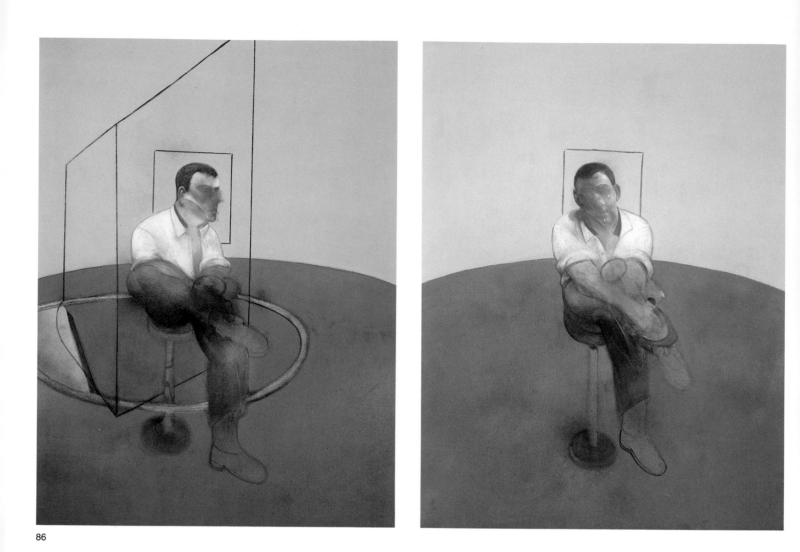

86

early 1970s gave way to a feeling of freshness in such images as
Three Studies for a Portrait of John Edwards (1984). "When you
are painting somebody, you know that you are, of course, trying
to get near not only to their appearance but also to the way they
have affected you, because every shape has an implication."[92] The
smears and distortions of earlier portraits had subsided by the late
1970s, as clusters of diagonal hatchmarks veil and soften the fea-
tures of such images as *Study for Portrait (Michel Leiris), John
Edwards,* and *Study for Self-Portrait* (1982).

Personal subject matter is paralleled by the more universal con-
tent of paintings that allude to the mythical suffering of Prometheus
and Orestes. The confrontation with mortality that underlies so
many portraits and triptychs of the 1970s is amplified in a succes-
sion of works that draw on the imagery of *Painting 1946* and trace
the gloomy course of the Furies. *Second Version of "Painting 1946"*
was made in 1971, when the Museum of Modern Art in New York
seemed reluctant to lend the original version to the Grand Palais
for Bacon's retrospective. The work of 1946 was finally made
available for the show, but in the meantime Bacon had recast the
image, to insure its inclusion in one form or another, from a
vantage point transformed by the intervening twenty-five years.

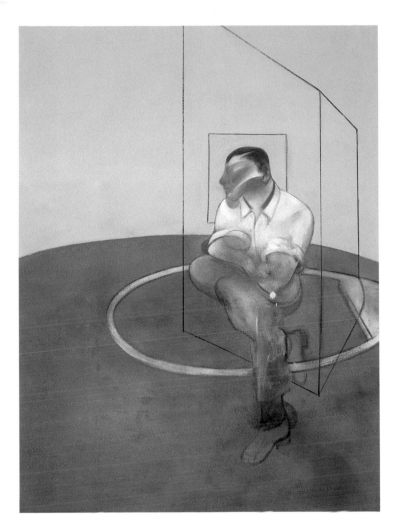

86. *Three Studies for a Portrait of John Edwards*, 1984
Oil on canvas, triptych, each panel 78 x 58 in.
Collection of the artist

See pages 90, 91:

87. *Second Version of "Painting 1946,"* 1971
Oil on canvas, 78 x 58 in.
Museum Ludwig, Cologne

88. *Seated Figure,* 1978
Oil on canvas, 78 x 58 in.
Private collection, New York

In style and content the later painting is considerably less fierce than that of 1946. The composition is more clear and spare, the magenta background replaced by bright yellow. While the musculature of the arms of the split carcass is even more distinctly human than before, the central figure is, quite simply, a different person. Though his eyes remain obscured by the umbrella, his neck no longer bulges brutishly, and he is more relaxed, the growling mouth replaced by a more conversational arrangement of the lips. The laced boots worn by the figure are familiar from images of Lucian Freud and of Bacon himself. Neatly dressed, wearing a raincoat over his suit, he looks more like a banker off to lunch in the rain than a vicious dictator shrieking at a crowd.

The taming of the violent imagery of *Painting 1946* continues in *Seated Figure* (1978). The figure is enclosed within the familiar linear cube, beyond which three pink shades with tassel pulls reiterate the setting of both versions of *Painting 1946*. But the carcass and the railings skewered with meat have been eliminated. The figure is now dressed in white cricketers' clothes, and his teeth protrude awkwardly rather than menacingly. Below this figure hovers a bust of George Dyer, ideally handsome; with the passing of time, the image of Dyer once again coheres.

88

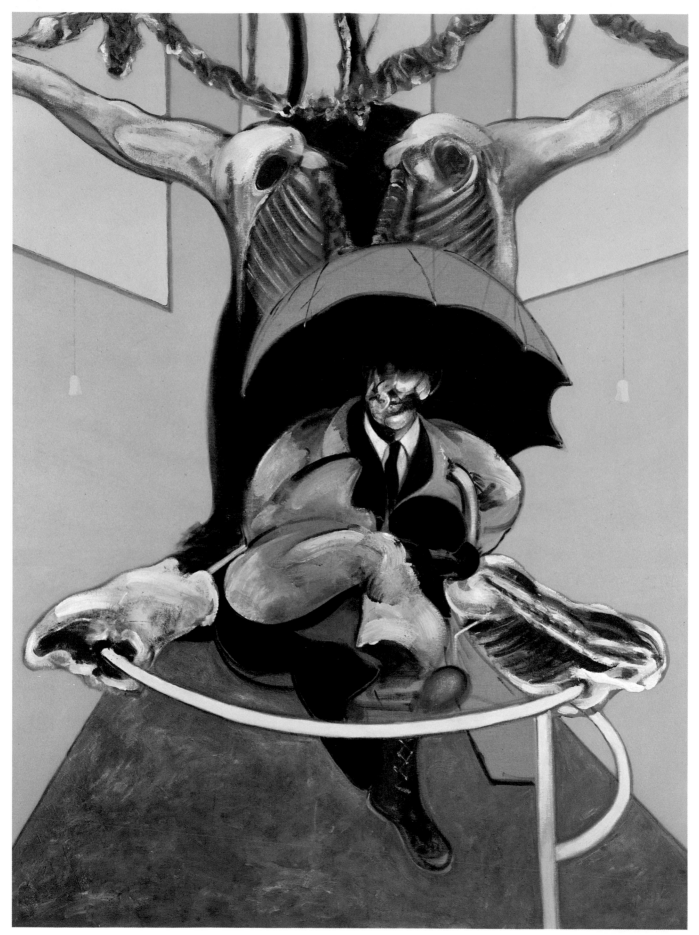

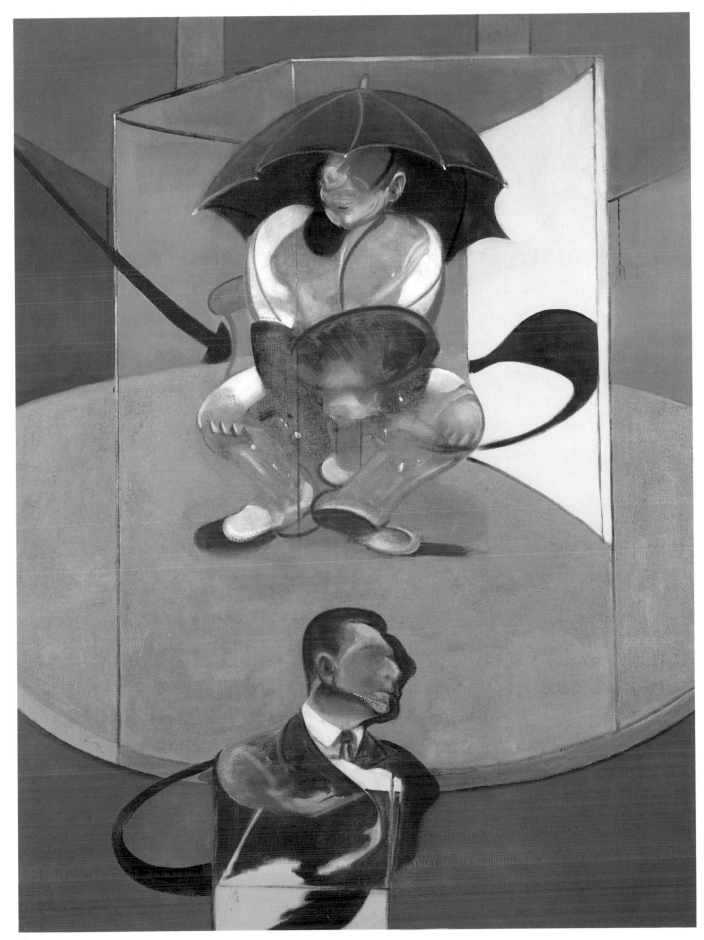

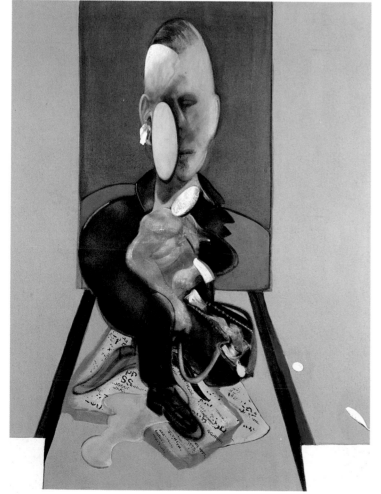

89

89. *Triptych*, 1976
Oil and pastel on canvas, triptych,
each panel 78 x 58 in.
Private collection, France

Five years after completing *Second Version of "Painting 1946,"* Bacon returned to the imagery of 1946 to create a triptych that again juxtaposed villain and victim. The central panel of *Triptych* (1976) revolves around the image of a headless figure, apparently painted on a canvas or reflected in a mirror. It is seated on a chair, its legs horrifyingly lively in their springiness. In pose and ashen pallor, this figure reads like a curious revamping of the headless, armless goddess variously identified as Leto or Hestia, of the fifth century B.C., among the Elgin marbles in the British Museum in London.[93] A bird of prey attacks the decapitated figure, while vulturelike creatures perch on railings. In its suggestion of a living human victim of a predatory bird the image calls to mind the story of Prometheus. In the foreground a bowl suggesting both a chalice and a toilet overflows, its contents blood red. The sleek lines and surfaces of the railing establish a counterpoint to the visceral forms of the human carrion and its attackers. At right and left the faces of two men loom large, like propaganda posters. They are stony, ambiguous figures, who seem implicated by their proximity and by their dispassion in the violence recorded in the center panel.

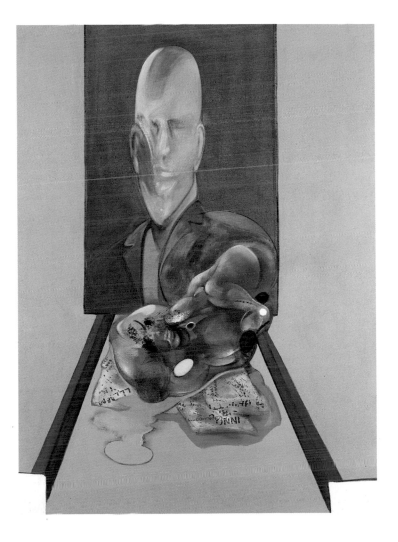

The strange, posterlike heads of *Triptych* (1976) are echoed in
91 *Triptych* (1974–77) by the large heads that bracket a nude figure.
In a palette recalling Picasso's Dinard bathers, the sky blue background and sand-colored ground plane of the central image are restated in the beach settings of the side panels, each containing a figure elevated on a "chaise" of wood and tubular construction and sheltered by a black umbrella. While the large heads were images that Bacon had often thought about, the horses and riders at left, inspired by Degas, were "an afterthought" incorporated for the "distance and movement" they would add.[94] The dramatic difference in scale between the distant horses and the heads was
92 intensified in *Statue and Figures in a Street* (1983). Tiny, dark figures, akin to those that populate the paintings of French artist Henri Michaux, move along the street, dwarfed by the huge statue and by the even more vast plane against which it is isolated. The human figure is overpowered, as by the insistent repetitions and disproportionately vast scale of Fascist architecture.

90. *Landscape*, 1978
Oil and pastel on canvas, 78 x 58 in.
Private collection

91. *Triptych*, 1974–77
Oil and pastel on canvas, triptych,
each panel 78 x 58 in.
Collection of the artist

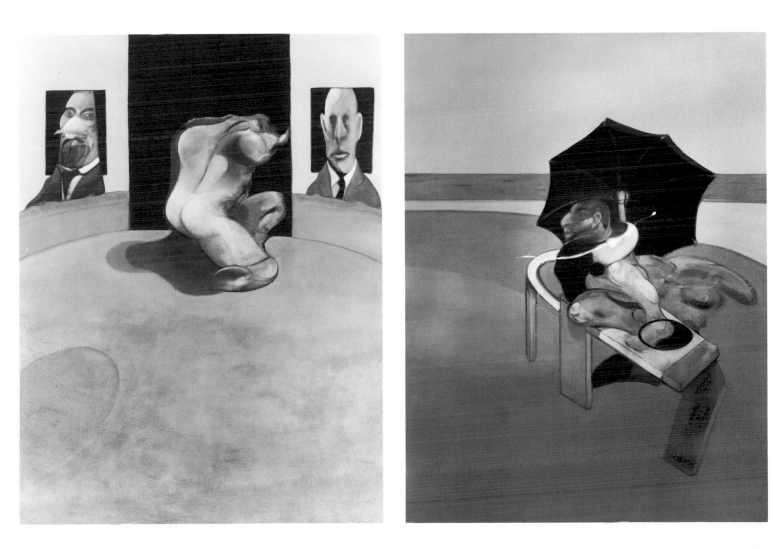

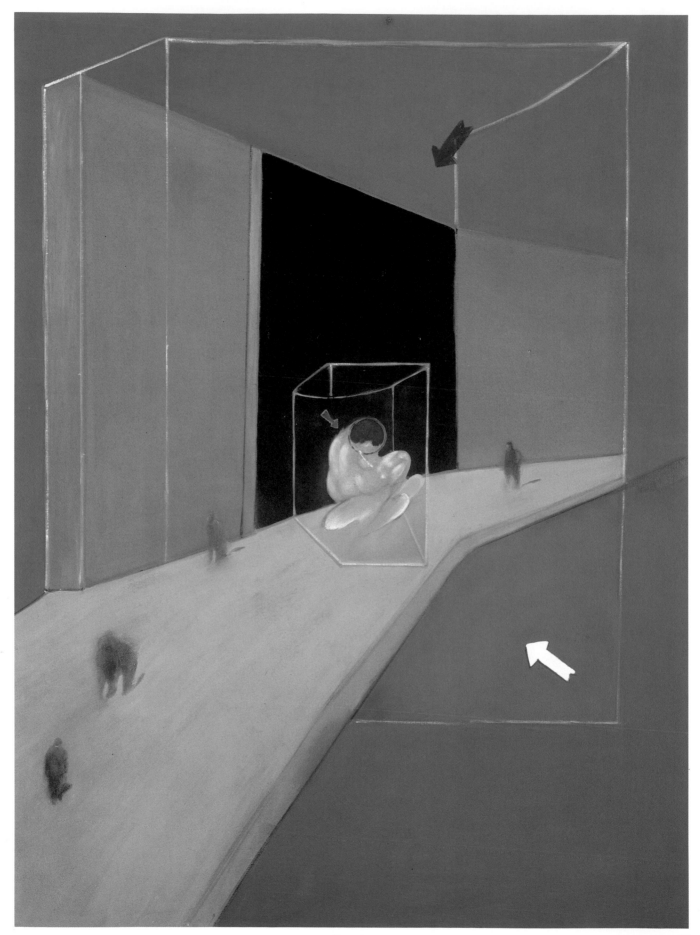

92. *Statue and Figures in a Street*, 1983
Oil and pastel on canvas, 78 x 58 in.
Collection of the artist

93. *Jet of Water*, 1979
Oil on canvas, 78 x 58 in.
Private collection

94. *Sand Dune*, 1981
Oil and pastel on canvas, 78 x 58 in.
Private collection, New York

93 94

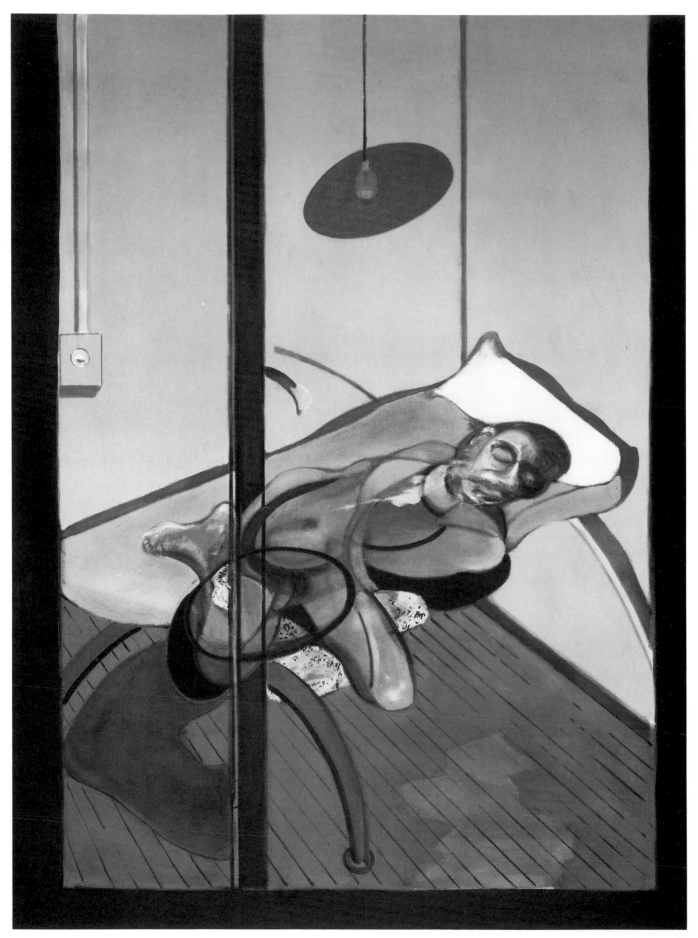

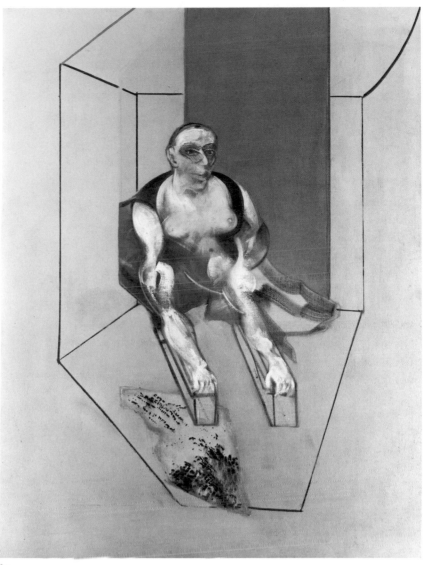

96

Bacon's sense of the poignancy of our condition—our helplessness in the face of an apparently indifferent universe—inflects the paintings of the past decade and a half. The fragility of the human form is suggested with gentle introspection in *Sleeping Figure* (1974), 95 whose huddled subject seems considerably more ephemeral than his own shadow. The nullity of death was defied in *Sphinx—Portrait* 96 *of Muriel Belcher* (1979), as Bacon rendered his robust old friend, during the year of her death, in the guise of an ageless, ancient creature.

Within the context of these reveries on finitude, the threshold assumes momentous importance in Bacon's art. As in the black triptychs and in the *Oresteia* itself, the dark events of *Triptych,* 97 *1981, Inspired by the Oresteia of Aeschylus* are set before doorways. Part bird of prey, part mammal, the bloodied embodiment of the Erinyes of Aeschylus—which for Bacon is an "image of disaster"[95]—seems momentarily snared within the schematic spatial structure at left. Tireless pursuers of men, the Erinyes appear with greatest clarity in a painting of 1974, *Seated Figure.*[96] Dressed in 98 black shorts, the seated figure twists his head away, to escape the

99

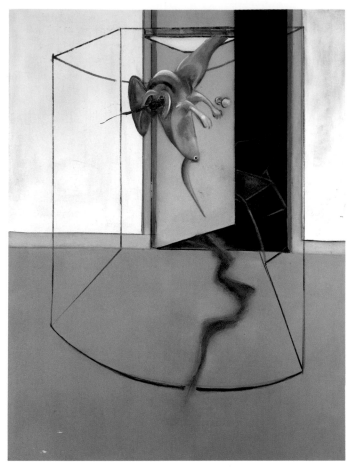

97

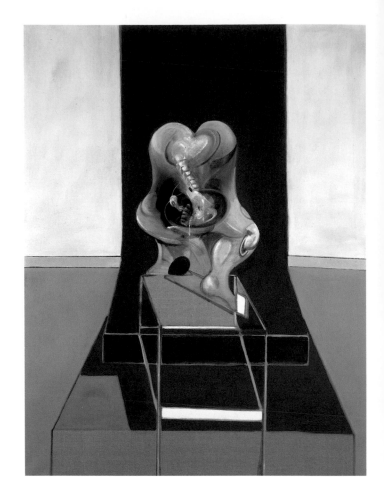

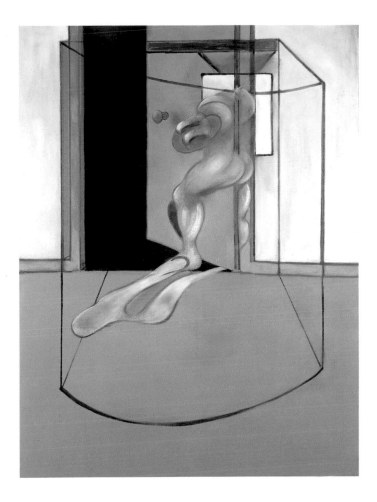

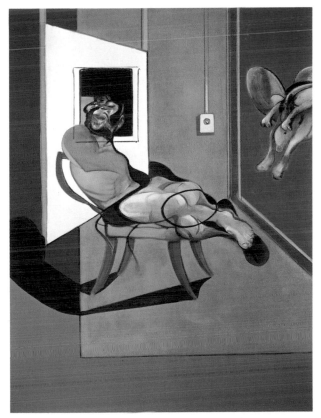

97. *Triptych, 1981, Inspired by the Oresteia of Aeschylus*, 1981
Oil on canvas, triptych, each panel 78 x 58 in.
Marlborough International Fine Art

98. *Seated Figure*, 1974
Oil and pastel on canvas, 78 x 58 in.
Gilbert de Botton, Switzerland

98

hideous creature who hovers at right. The four limbs and oddly fleshy wings of this predatory being shockingly identify in retro-spect the shadowed presence in the central panel of *Triptych, May–June* (1973) and call to mind Bacon's reflection that in modern life the Erinyes take the form of our private demons. "We are al-ways hounding ourselves. We've been made aware of this side of ourselves by Freud, whether or not his ideas worked thera-peutically."[97]

An arrow points toward a bloodied opening in the body of the now familiar incarnation of the Furies in *Oedipus and the Sphinx after Ingres* (1983). This repugnant creature is suspended beyond the doorway of the brightly lit room where Oedipus and the Sphinx meet, taking the place of Oedipus's companion in Ingres's painting of 1808 (reworked in about 1827). The black washes across the face and eyes of the heroically muscled figure of Oedipus fore-shadow his blindness and distinguish him from Ingres's clearly illuminated, pristine figure. Perhaps inspired by the pair of javelins resting next to the protagonist's left foot in the original painting, Bacon has shown Oedipus's left foot, attached to his right leg, bandaged and bloody, recalling the piercing of his feet in infancy before his parents abandoned him to die in a doomed effort to outwit their destiny of patricide and incest. The story may have appealed to Bacon because of the unwitting complicity of its pro-tagonists in the designs of fate. But the role of fate suggested here is to some degree an indulgence on Bacon's part, as he recapitu-lates a story and outlook that belong to another era, when the gods and the Fates figured as real forces.

Bacon's paintings are, in the end, about what we do in that space that we are allowed: "we are born and we die, but in between we give this purposeless existence a meaning by our drives."[98] In *Study of the Human Body* (1983), a spectral figure, legs straining as though at the end of a long climb, steps toward a doorway, arm reaching for the lock, calling to mind the macabre lingo of the chorus at the end of Eliot's "Sweeney Agonistes":

And you wait for a knock and the turning of a
 lock for you know the hangman's waiting for you.
And perhaps you're alive
And perhaps you're dead
Hoo ha ha . . .
Knock
Knock[99]

Early on, Bacon identified his subject matter: the raw facts of human existence. Tinged by his conviction that ours is a world devoid of any benevolent plan, his paintings defy the cosmic senselessness of our actions as they focus with vehemence, tender-ness, remorse, and a plethora of other emotions on the private lives of their subjects. "If you talk about futility you have to be grand like Shakespeare's *Macbeth*. . . ."[100] And it is with grandeur, and a carefully metered formality, that Bacon's paintings "rein-vent . . . what we know of our existence . . . tearing away the veils."[101]

99. *Study of the Human Body*, 1983
Oil and pastel on canvas, 78 x 58 in.
Menil Foundation Collection, Houston

See page 104:

100. *Oedipus and the Sphinx after Ingres*, 1983
Oil on canvas, 78 x 58 in.
Private collection, California

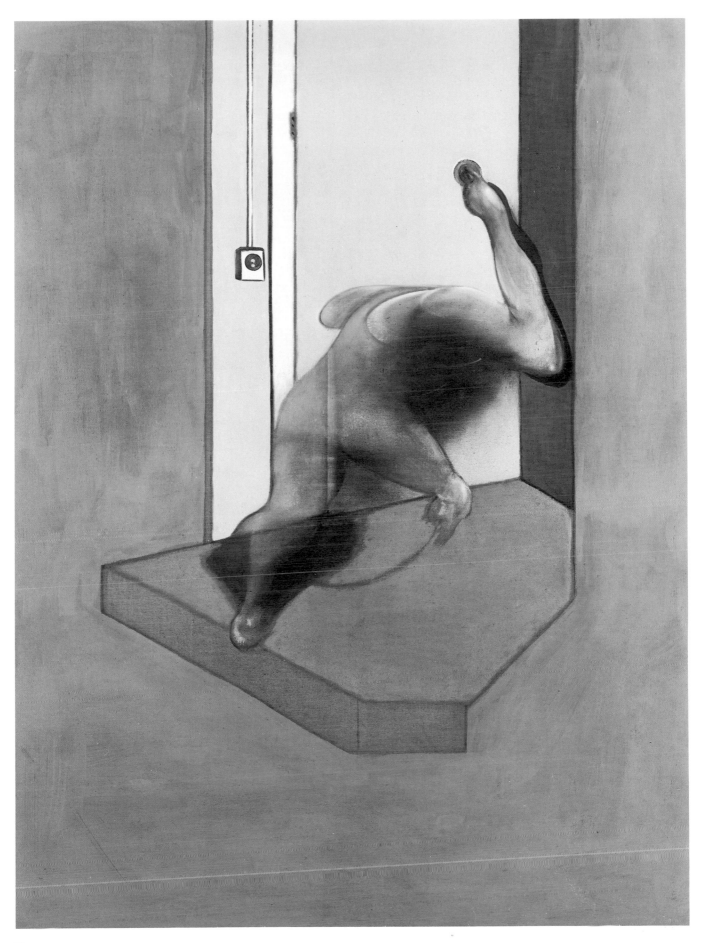

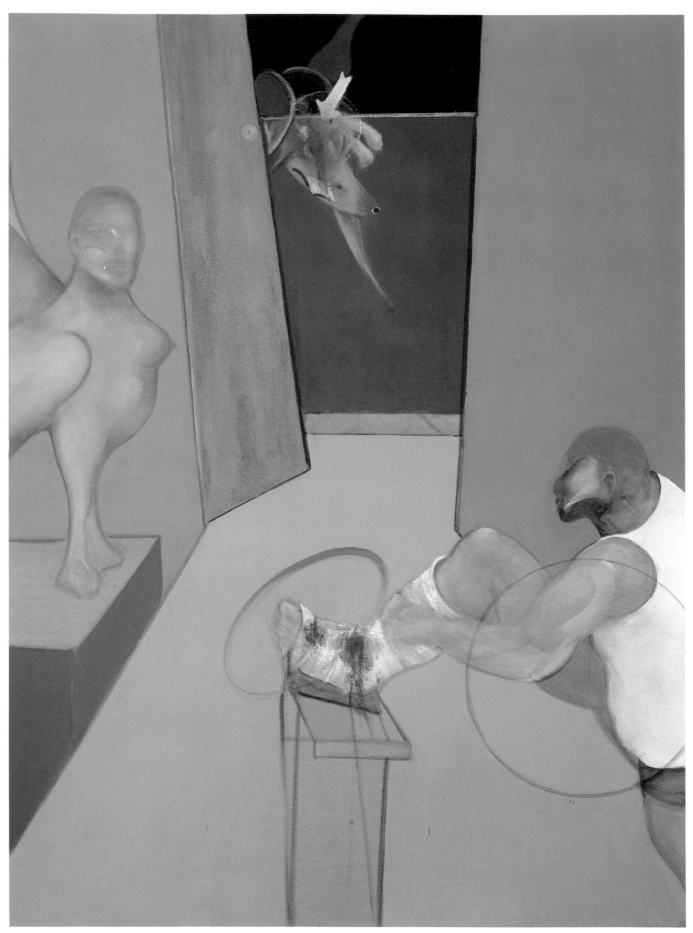

NOTES

1. David Sylvester, *Interviews with Francis Bacon, 1962–1979* (London: Thames and Hudson, 1980), p. 17.

2. Francis Bacon, interview by Hugh Davies, March 17, 1973, London.

3. Sylvester, *Interviews*, pp. 58, 60.

4. Ibid., pp. 133, 83.

5. Francis Bacon, interview by Hugh Davies, April 12, 1973, London.

6. Sylvester, *Interviews*, pp. 52, 121–22.

7. William Bedell Stanford, *Aeschylus in His Style* (Dublin: Dublin University Press, 1942), p. 109. Bacon discussed his admiration for Stanford's book in an interview with Hugh Davies, May 19, 1973, London.

8. Letter from van Gogh to his brother Theo, summer 1885, *The Complete Letters of Vincent van Gogh* (Greenwich, Ct.: New York Graphic Society, 1959), p. 401. For Bacon's paraphrase, see "Francis Bacon and David Sylvester: An Unpublished Interview," in *Francis Bacon: Peintures récentes* (Paris: Galerie Maeght-Lelong, 1984), p. 29.

9. Sylvester, *Interviews*, p. 30.

10. Ronald Alley and John Rothenstein, *Francis Bacon* (London: Thames and Hudson, 1964), p. 8; Bacon rephrased his original remarks slightly in a conversation with Hugh Davies, May 23, 1985.

11. Francis Bacon, interview by Hugh Davies, April 3, 1973, London.

12. Ibid.

13. Francis Bacon, interview by Hugh Davies, June 26, 1973, London.

14. John Rothenstein, *Modern English Painters: Volume II, Lewis to Moore* (London: Eyre and Spottiswoode, 1956), p. 259.

15. Bacon, interview by Davies, March 17, 1973.

16. Sir Roland Penrose, interview by Hugh Davies, March 29, 1973, London. Sir Roland added, almost apologetically, "He's destroyed so much from that time and become more surreal in his later work." The exhibition was accompanied by a catalog with an introduction by Herbert Read. Penrose generously allowed Davies to look at installation photographs of the exhibition.

17. Sylvester, *Interviews*, p. 76.

18. The Tate triptych was conceived as "sketches for the Eumenides (the Greek Furies) which I intended to use as the base of a large Crucifixion which I may do still." Letter from Bacon, January 9, 1959, quoted in Alley and Rothenstein, *Francis Bacon*, p. 35.

19. In creating his contemporary triptychs Bacon usually begins with the left panel and works across to the right.

20. Alley and Rothenstein, *Francis Bacon*, pp. 35, 33. Grünewald's *The Mocking of Christ* is in the Alte Pinakothek in Munich. Alley and Rothenstein record the fact that in "the later 'thirties Bacon became particularly interested in photographs of Hitler and Mussolini when these began to reach England." Photographs of Hitler, Himmler, and Goebbels were among the images scattered around Bacon's studio when Sam Hunter visited in 1950. Hunter assembled the newspaper clippings, magazine illustrations, reproductions from art books, and other visual sources that he had come upon and photographed them for reproduction in his landmark article "Francis Bacon: The Anatomy of Horror," *Magazine of Art 95* (January 1952): 12.

21. Alley and Rothenstein (*Francis Bacon*, p. 36) mention the photograph of Hall, which no longer exists. Bacon confirmed that the photo had served as a source for *Figure in a Landscape* and identified the brown V-shape form projecting toward the figure as a pair of microphones. Interview by Davies, May 19, 1973. It seems probable that the man-before-microphones motif was adapted from a news photo of Hitler or some other political propagandist. Eric Hall owned *Three Studies for Figures at the Base of a Crucifixion* before presenting it to the Tate in 1953.

22. Bacon has repeated this explanation to several writers: interview by Davies, April 3, 1973; Alley and Rothenstein, *Francis Bacon*, p. 12; John Russell, *Francis Bacon* (Greenwich, Ct.: New York Graphic Society, 1971), pp. 48, 57. Russell explains that the work began with an image of a chimpanzee in long grass, which gave way to the image of the bird. Bacon recalled (interview by Davies, April 3, 1973) that any trace of the bird had disappeared very early in the process of unconsciously coaxing out the image of the dictator.

23. Russell, *Francis Bacon*, p. 57.

24. Francis Bacon, interview by Hugh Davies, August 7, 1973, London.

25. Alley and Rothenstein, *Francis Bacon*, pp. 40, 277.

26. Sylvester, *Interviews*, p. 51.

27. Bacon, interview by Davies, June 26, 1973.

28. Russell, *Francis Bacon*, pp. 71–72.

29. Bacon has never been to see the original *Portrait of Pope Innocent X* in the Palazzo Doria in Rome, though he has visited Rome several times. Rothenstein recounts (Alley and Rothenstein, *Francis Bacon*, p. 13): "'Have you ever seen it?' I asked him. 'Never,' he replied; 'when I was in Rome I felt reluctant to look at it.'"

30. "Survivors," *Time 54* (November 21, 1949): 44.

31. Alley and Rothenstein, *Francis Bacon*, p. 17.

32. Van Deren Coke, *The Painter and the Photograph: From Delacroix to Warhol* (Albuquerque: University of New Mexico Press, 1964), p. 165.

33. Karen Blixen, *Out of Africa* (New York: Random House, 1937), p. 93.

34. Francis Bacon, interview by David Sylvester, in *Francis Bacon: Fragments of a Portrait*, a film for BBC Television, London, 1966; published as "From Interviews with Francis Bacon," in *Francis Bacon: Recent Paintings*, exhibition catalog (London: Marlborough Fine Art Ltd., 1967), p. 34.

35. Bacon, interview by Davies, March 17, 1973.

36. Bacon, interview by Davies, June 26, 1973.

37. Alley and Rothenstein, *Francis Bacon*, p. 53.

38. Sylvester, *Interviews*, pp. 48, 50. Andrew Hammer ("Exhibitions," *Architectural Review* 111 [February 1952]: 133) observed that "Bacon places the Pope in a chair that has been wired to the mains. . . ." Bacon, however, recalls that he did not conceive of the pope as being electrocuted. Interview by Davies, April 3, 1973.

39. Bacon, interview by Davies, June 26, 1973.

40. Alley and Rothenstein, *Francis Bacon*, p. 72.

41. Sam Hunter, "Francis Bacon: An Acute Sense of Impasse," *Art Digest 28* (October 15, 1953): 16.

42. Bacon has acknowledged the importance of Muybridge for his work. When asked by interviewer Gavin Millar about the respective influences of Marey and Muybridge, Bacon responded: "More from Muybridge than Marey although I think Marey did, you could say, more beautiful images, but not so important from my point of view because they both concentrated on movement of the body and I find that Muybridge is more stimulating. You may say Muybridge's are just raw statements of movement. You know he had nine cameras in different positions. . . ." Asked if his interest in these studies of the body related to their accuracy or derived from their expression of something beyond simple movement, he replied: "Well two things, both. One is that they're the alterations of the muscular structure of the body but then every movement of the body has another intonation because every way that a person moves, stands, moves their arms or anything else has not only its movement but, you may say, all the implications of that movement as well." Interview by Gavin Millar, in *Francis Bacon: Grand Palais*, a film for BBC Television, London, 1971.

43. Bacon, interview by Davies, May 19, 1973.

44. Bacon, interview by Davies, June 26, 1973.

45. Alley and Rothenstein, *Francis Bacon*, p. 80.

46. Sylvester, *Interviews*, pp. 34, 72.

47. Russell, *Francis Bacon*, p. 129.

48. Sylvester, "From Interviews with Francis Bacon," pp. 30–31.

49. Sylvester, *Interviews*, p. 63.

50. Coke, *The Painter and the Photograph*, p. 35.

51. Sylvester, *Interviews*, p. 74.

52. Ibid., p. 116.

53. Bacon, interview by Davies, August 7, 1973.

54. Alley and Rothenstein (*Francis Bacon*, p. 111) note that Bacon worked from a color reproduction in the Phaidon *Van Gogh* volume and observe that Bacon transformed the palette

drastically. The van Gogh painting was destroyed by fire during World War II, and Bacon had not seen the original. Bacon, interview by Davies, April 3, 1973.

55. Bacon, quoted in Russell, *Francis Bacon*, p. 91.

56. Bacon, interview by Davies, April 3, 1973. For Bacon and Newman, see Russell, *Francis Bacon*, p. 172.

57. Francis Bacon, conversation with Hugh Davies and Sally Yard, March 20, 1975, New York.

58. Sylvester, *Interviews*, pp. 38, 40.

59. Francis Bacon, interview by Hugh Davies, August 13, 1973, London.

60. While Bacon himself has a round-cornered bed, he recalls that he had painted the curving beds before he owned his: "It's from one in an old, broken-down Arab hotel in North Africa." Bacon, interview by Davies, August 7, 1973.

61. Dawn Ades ("Web of Images," in *Francis Bacon*, exhibition catalog [London: Tate Gallery, 1985], p. 16) has recently considered the vertical inversion of Bacon's lying figures in relation to Freudian psychology.

62. Sylvester, *Interviews*, p. 78; Bacon, interview by Davies, August 7, 1973. Bacon has explained that he uses such "visual rivets" as the hypodermic syringe, blind cords, and hanging light bulbs because they "arrest the eye." Bacon, interview by Davies, March 17, 1973.

63. Sylvester, *Interviews*, p. 28.

64. Bacon, interview by Davies, August 13, 1973.

65. Sylvester, *Interviews*, p. 23.

66. Russell, *Francis Bacon*, p. 208.

67. Bacon, interview by Davies, August 13, 1973.

68. Bacon, interview by Davies, August 7, 1973.

69. Sylvester, *Interviews*, p. 90.

70. A photograph of Dyer dressed in this manner is among those taken by Bacon's friend John Deakin, a professional photographer, for use in triggering portraits. Bacon, interview by Davies, April 3, 1973.

71. Bacon, interview by Davies, April 13, 1973; Francis Bacon, interview by Hugh Davies, September 7, 1983, London.

72. Sylvester, *Interviews*, pp. 56–57.

73. Ibid., p. 86.

74. T. S. Eliot, "Sweeney Agonistes" (1932), in *Collected Poems 1909–1935* (New York: Harcourt, Brace and Company, 1936), p. 150. Russell (*Francis Bacon*, p. 227) explains that the central panel was "sponsored . . . by the reminiscence of a particularly enigmatic crime of the 1920s. . . ."

75. Rolf Laessoe, "Francis Bacon and T. S. Eliot," *Hafnia: Copenhagen Papers in the History of Art* 9 (1983): 116.

76. Eliot, "Sweeney Agonistes," p. 147.

77. Sylvester, *Interviews*, pp. 22, 65.

78. Ibid., p. 41, figure 39.

79. Francis Bacon, interview by Hugh Davies, March 6, 1973, London.

80. Sylvester, *Interviews*, p. 78.

81. Ibid., p. 40.

82. Claude Monet, conversation with Georges Clemenceau, quoted in Douglas Cooper, *Claude Monet*, exhibition catalog (London: Tate Gallery, 1957), p. 13.

83. Bacon claims that he adopted the device of the arrows from a book on golfing instruction in which arrows indicated the direction of

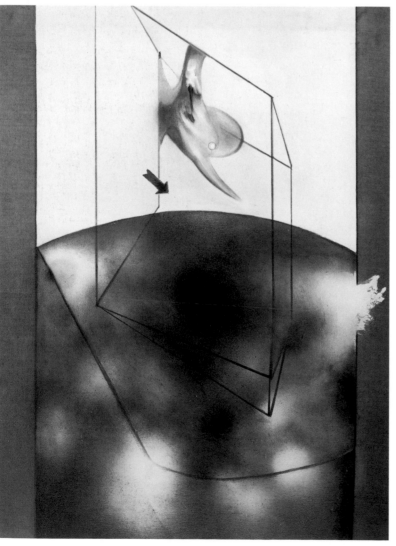

101. *Painting, March*, 1985
Oil on canvas, 78 x 58 in.
Collection of the artist

102. *Figure in Movement*, 1985
Oil on canvas. 78 x 58 in.
Collection ot the artist

101

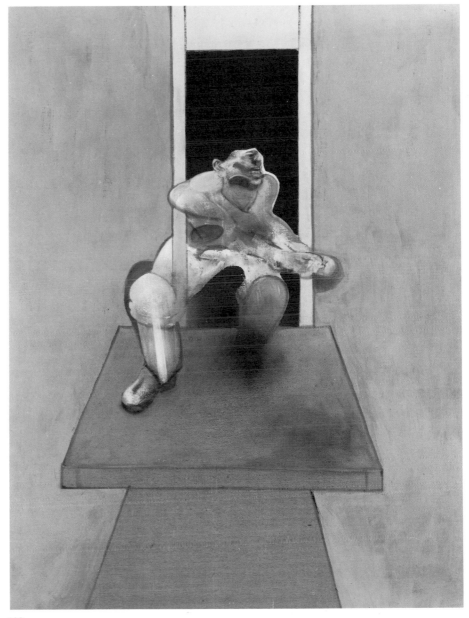

102

a drive. His intention was to neutralize the lurid content of the image, allowing it to be viewed with a detachment akin to that of medical textbooks. Bacon, interview by Davies, April 3, 1973.

84. Bacon, interview by Davies, August 13, 1973. Bacon did not intend but has acknowledged the resemblance of the cameraman to himself. The relationship of the figures and railing brings to mind Bacon's thoughts on creating sculptures composed of anatomical forms positioned on polished steel railings. Having "been able to incorporate the sculptural in my painting," Bacon has never made any sculpture. Bacon, interview by Davies, April 3, 1973.

When asked if the Letraset letters *BRAC* were intended as a reference to the Cubist painting and collage of Braque, Bacon explained that the passage was supposed to look like news-

paper, but that he had deliberately avoided using real newspaper or spelling things out so that people would not try to read meaning into the arrangements of letters. Ibid.

85. Sylvester, *Interviews*, p. 120.

86. Michel Leiris, "What Francis Bacon's Paintings Say to Me," in *Francis Bacon: Recent Paintings*, p. 24. Bacon has often cited this remark by Cocteau (Sylvester, *Interviews*, p. 133) and has spoken of his interest in Clark's book (ibid., pp. 30, 32).

87. Ades, "Web of Images," p. 16.

88. Sylvester, *Interviews*, pp. 46–47.

89. Duchamp, quoted ibid. p. 104

90. Sylvester, *Interviews*, p. 118.

91. Ibid., p. 129.

92. Ibid., p. 130.

93. Bacon has noted that "the Elgin Marbles in the British Museum are always very impor-

tant to me, but I don't know if they're important because they're fragments, and whether if one had seen the whole image they would seem as poignant as they seem as fragments." Sylvester, *Interviews*, p. 144.

94. Ibid., p. 138.

95. Bacon, interview by Davies, September 7, 1983. In this same conversation Bacon remarked that he had often consulted the illustrations in books on birds of prey.

96. Sylvester, *Interviews*, p. 112.

97. Bacon, interview by Davies, September 7, 1983.

98. Sylvester, *Interviews*, p. 134.

99. Eliot, "Sweeney Agonistes," pp. 153–54.

100. Bacon, interview by Davies, April 3, 1973.

101. Bacon, interview by Davies, June 26, 1973.

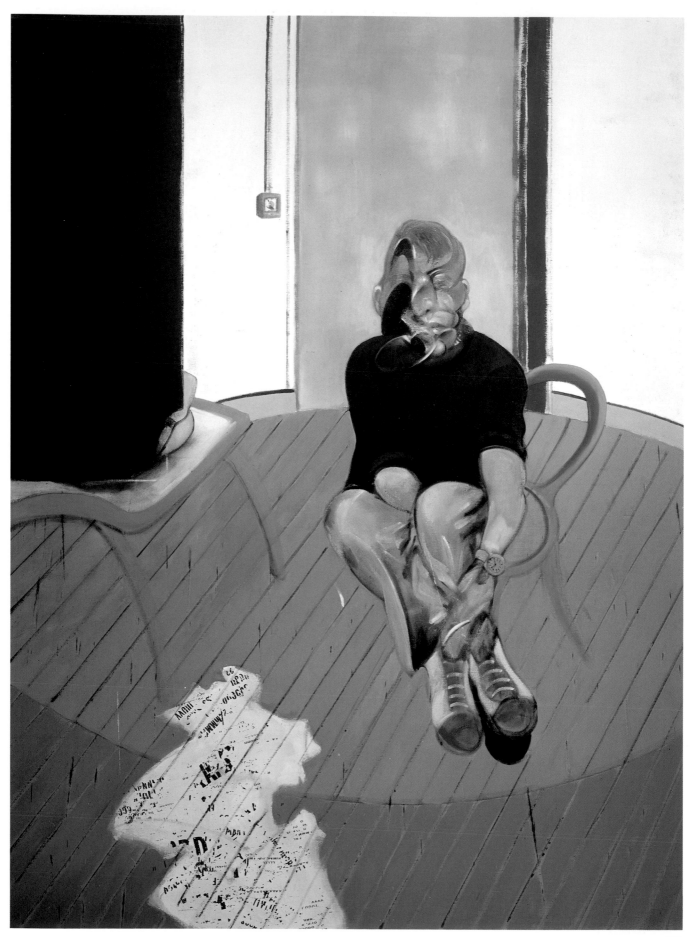

Artist's Statements

Everybody has his own interpretation of a painting he sees. I don't mind if people have different interpretations of what I have painted. . . . A picture should be a re-creation of an event rather than an illustration of an object; but there is no tension in the picture unless there is the struggle with the object.

> From an unpublished 1952 interview by *Time*, quoted in Andrew Carnduff Ritchie, ed., *The New Decade: 22 European Painters and Sculptors*, exhibition catalog (New York: Museum of Modern Art, 1955), p. 60.

I would like my pictures to look as if a human being had passed between them, like a snail, leaving a trail of the human presence and memory trace of past events, as the snail leaves its slime. I think the whole process of this sort of elliptical form is dependent on the execution of detail and how shapes are remade or put slightly out of focus to bring in their memory traces.

> From *The New Decade: 22 European Painters and Sculptors*, p. 63.

I think that great art is deeply ordered. Even if within the order there may be enormously instinctive and accidental things, nevertheless I think that they come out of a desire for ordering and for returning fact onto the nervous system in a more violent way. Why, after the great artists, do people ever try to do anything again? Only because, from generation to generation, through what the great artists have done, the instincts change.

> From a 1966 interview in David Sylvester, *Interviews with Francis Bacon, 1962–1979* (London: Thames and Hudson, 1980), p. 59.

But this violence of my life, the violence which I've lived amongst, I think it's different to the violence in painting. When talking about the violence of paint, it's nothing to do with the violence of war. It's to do with an attempt to remake the violence of reality itself. . . . When I look at you across the table, I don't only see you but I see a whole emanation which has to do with personality and everything else. And to put that over in a painting, as I would like

103. *Self-Portrait*, 1973
Oil on canvas, 78 x 58 in.
Private collection

to be able to do in a portrait, means that it would appear violent in paint.

From interviews of 1971–73, in Sylvester, *Interviews*, pp. 81–82.

It's also always hopeless talking about painting—one never does anything but talk around it—because, if you could explain your painting, you would be explaining your instincts.

From interviews of 1971–73, in Sylvester, *Interviews*, p. 100.

I rely on chance as much as possible and push the paint around until something happens. I think of myself as an instinctual painter, being as close as possible to the nervous system and the unconscious. . . . One doesn't know what one's instinct is, why one retains one hazardous mark rather than another. You hope that you change altogether through time. People don't ever stand still, they're in movement from birth to death, the whole psyche is changing all the time. No one ever knows what their psyche ever is.

We don't know how the nervous system works, there is this deep well from which things are drawn out, a reservoir of the unconscious. I don't know if it's true. In my things I'd like them to be in one sense very exact but you couldn't tell what the exactitude is, mysterious because how they come about is mysterious, images which unlock other images.

From interviews with Hugh Davies, March 6 and August 7, 1973, London.

Great art is always a way of concentrating, reinventing what is called fact, what we know of our existence—a reconcentration . . . tearing away the veils that fact acquires through time. Ideas always acquire appearance veils, the attitudes people acquire of their time and earlier time. Really good artists tear down those veils.

From an interview with Hugh Davies, June 26, 1973, London.

People always seem to think that in my paintings I'm trying to put across a feeling of suffering and the ferocity of life, but I don't think of it at all in that way myself. You see, just the very fact of being born is a very ferocious thing, just existence itself as one goes between birth and death. It's not that I want to emphasize that side of things—but I suppose that if you're trying to work as near to your nervous system as you can that's what automatically comes out. . . . Life . . . is just filled, really, with suffering and despair.

From an interview with Miriam Gross, "Bringing Home Bacon," *Observer*, November 30, 1980, p. 29.

Francis Bacon One always starts work with the subject, no matter how tenuous it is, and one constructs an artificial structure by which one can trap the reality of the subject-matter that one has started from.

104

David Sylvester The subject's a sort of bait?

Francis Bacon The subject *is* the bait, but the bait withers away and the reality of the subject-matter is left and the bait—the subject-matter—disappears. The reality is the residue of the subject-matter. . . . This residue . . . perhaps has something tenuously to do with what one started with but very often had very little to do with it.

From a 1982 interview in "Francis Bacon and David Sylvester: An Un-published Interview," in *Francis Bacon: Peintures récentes* (Paris: Galerie Maeght-Lelong, 1984), p. 32.

104. *Self-Portrait*, 1970
Oil on canvas, 60⅛ x 58 in.
Private collection

105. *Study for Self-Portrait*, 1982
Oil on canvas, 78 x 58 in.
Private collection, New York

105

Notes on Technique

Bacon begins to paint by morning light and stops by the time the light fades. Yet the only natural light in his working space emerges from a tapering shaft leading to a square skylight and is augmented by two naked bulbs hanging from the ceiling. While photographs of Bacon amidst the painterly debris that fills the studio in which he has worked for a quarter of a century suggest the improvisational character of his methods, Bacon has never been filmed or photographed at work. Painting is for him a solitary process; he does not employ an assistant, and only very occasionally has a friend been permitted in the studio while he paints.

By nature as well as avocation Bacon is a gambler. The risks he takes in the paintings are dictated by his goal: to achieve the freshness and spontaneity of a small sketch without sacrificing the grandeur of a well-composed large painting. The paintings are generally completed quickly, in a matter of weeks, and with intense concentration. Once the background has been summarily blocked in, the figure or figures are painted in a rash of semi-controlled marks. If the result is worth preserving, the background is then completed. Working without preparatory sketches or studies, Bacon embraces the suggestions of accident. "I rely on chance as much as possible and push the paint around until something happens. . . . I think of myself as an instinctual painter . . . being as close as possible to the nervous system and the unconscious."[1] Bacon destroys unsuccessful canvases in the way other painters tear up their sketches.

While the figures are painted in oil, which remains malleable while it slowly dries, the more opaque surfaces of acrylic and occasionally of house paint are sometimes used for the flatter background passages. Color, particularly orange, is at times heightened by the addition of pastel. Images are coaxed and commanded from the supple medium with materials ranging from Brillo pads to cashmere sweaters, as brushes are joined by rags, cotton wool, sponges, scrub brushes, garbage-can lids, paint-tube caps, the artist's hands, and whatever else he can find in the studio for the application and shaping of painterly passages. In order to agitate the composure of his paintings he often impetuously hurls pigment at the canvas. Thick impasto coexists with thinned washes of pigment and raw canvas, and sand and dust are occasionally

106 *Study of the Human Body—from a Drawing by Ingres*, 1982 (right-hand panel of diptych, 1982–84)
Oil and pastel on canvas, 78 x 58 in.
Collection of the artist

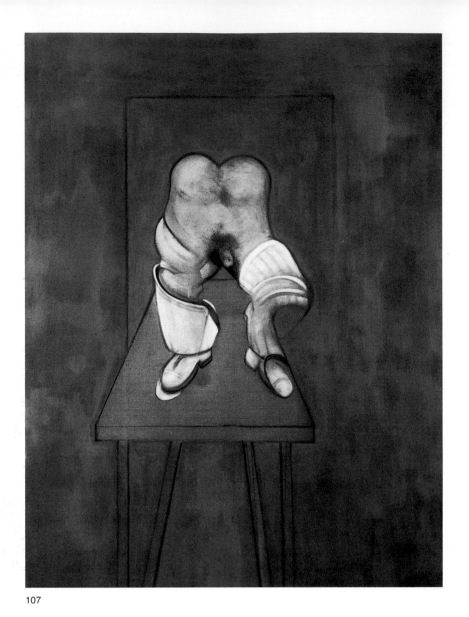

107. *Study of the Human Body*, 1982
Oil and pastel on canvas, 78 x 58 in.
Musée National d'Art Moderne, Centre
Georges Pompidou, Paris

108. Francis Bacon's studio, 1971. Photograph
by Henri Cartier-Bresson

107

used to give texture to the paint. A few works of the 1980s are
veiled in the haze produced by applying paint with an aerosol
spray. Bacon has used primed, stretched canvases since the 1944
Tate triptych, which was painted on board; but since 1947–48 he
has worked on the unprimed side, which in its absorbency and in
the visibility of its weave has suited his purposes.[2]

While Bacon's paintings range in size from the small portrait
heads to the large triptychs, the scale of his figurative images is
consistently nearly life-size. Probing his subjects in a succession of
paintings, Bacon has painted in series since 1949 and began to
make regular use of the triptych format in the early 1960s. "I often
daydream and images drop in hundreds at a time, some link up
with one another. I like the triptych format, layout, it breaks the
series up and prevents it having a story—that's why the three
panels are always framed separately."[3] He usually begins with the
left panel and works across, generally completing each canvas
before moving on to the next, but making revisions throughout as
the triptych nears completion.

"I look at everything from cave paintings to contemporary art
and I'm influenced by them all,"[4] Bacon has observed. Yet through-

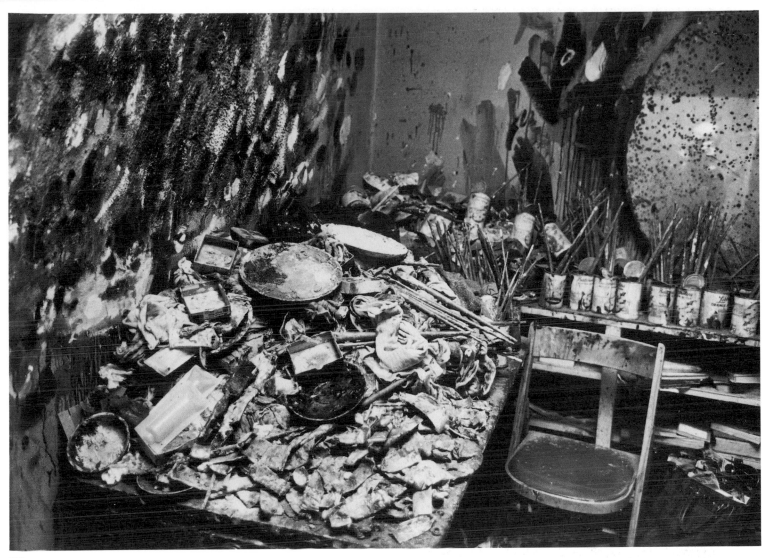

108

out his career he has aimed for the "National Gallery or the dustbin,"[5] conceiving his images within the tradition of the Grand Manner that guided European figure painting from the Renaissance into the nineteenth century.[6] Bacon's art is deeply dualistic—balancing the vivid and formal, integrating small-sketch immediacy and large-canvas stateliness, exploiting the tension between figurative resemblance and the abstracting accidents of process. With few exceptions, Bacon's paintings have been framed behind glass since the mid-1960s; the instinctual, raw images are presented with ceremony. "I don't believe art is available, it's rare and curious and should be completely isolated; one is more aware of its magic the more it is isolated."[7]

1. Francis Bacon, interview by Hugh Davies, March 6, 1973, London.
2. Andrew Durham, "Note on Technique," in Dawn Ades and Andrew Forge, *Francis Bacon*, exhibition catalog (London: Tate Gallery, 1985), pp. 231–32.
3. Francis Bacon, interview by Hugh Davies, April 3, 1973, London.
4. Bacon, interview by Davies, March 6, 1973.
5. John Russell, *Francis Bacon* (London: Thames and Hudson, 1971), p. 58.
6. Lawrence Alloway, introduction to *Francis Bacon*, exhibition catalog (New York: Solomon R. Guggenheim Museum, 1963), p. 16.
7. Francis Bacon, interview by Hugh Davies, March 17, 1973, London.

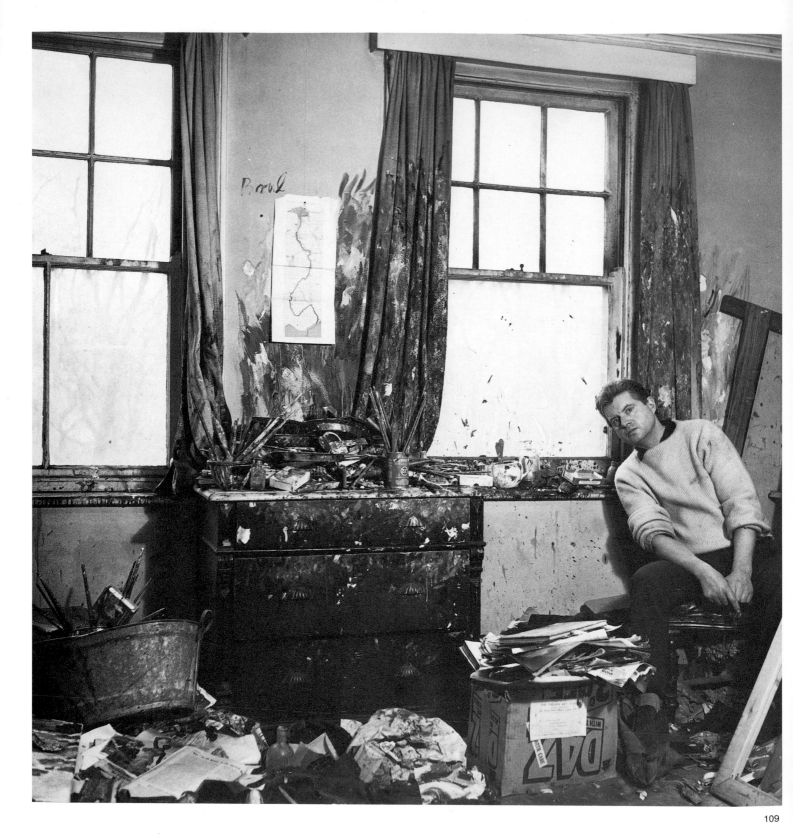

Chronology

By Daniel Starr

1909 October 28—born at 63 Lower Baggot Street, Dublin, to English parents, Edward and Winifred Bacon. He is a collateral descendant of Francis Bacon, the philosopher.

1914 The Bacon family moves to London, initiating a succession of shifts between England and Ireland.

1925 Bacon moves to London with a small allowance from his family; works for a few months in an office.

1927–28 Spends two months in Berlin, then travels to Paris, where he works now and then as an interior decorator. A Picasso exhibition at the Paul Rosenberg Gallery prompts him to consider becoming an artist, and he makes his first drawings and watercolors.

1929 Returns to London and sets up a studio at 7 Queensberry Mews, where he presents an exhibition of the furniture and rugs that he has designed. Begins to paint in oils.

1930 Exhibits his paintings and furniture together with paintings by Roy de Maistre in the Queensberry Mews studio.

1931 Moves to Fulham Road.

1933 Herbert Read reproduces *Crucifixion* (1933) in his book *Art Now*. Bacon moves to 71 Royal Hospital Road at about this time.

1934 February—installs an exhibition of his paintings at the Transition Gallery, Sunderland House. Spends less time painting.

1936 The works that he submits to the *International Surrealist Exhibition* in London are rejected as "insufficiently surreal." Moves to 1 Glebe Street around this time.

1937 January—three of his paintings are included in the exhibition *Young British Painters* at Thomas Agnew & Sons, London.

1941–44 Lives for a time in Petersfield, Hampshire. Returns to London and rents a studio at 7 Cromwell Place, where John Everett Millais had painted. Unsuited for military service because of asthma, Bacon works in the Civil Defense Corps rescue service. Destroys most of his early work.

1944 Resumes painting seriously. Introduces the theme of the Furies in *Three Studies for Figures at the Base of a Crucifixion*.

1945 April—two paintings included in a group exhibition at the Lefevre Gallery, London.

1946–50 Lives primarily in Monte Carlo, returning periodically to London. Develops a friendship with Graham Sutherland.

1948 Alfred H. Barr, Jr., buys *Painting 1946* for the Museum of Modern Art, New York.

1949 Completes the series of six Heads initiated the previous year. November–December—these Heads are included in his first solo exhibition at the Hanover Gallery, London, organized by Erica Brausen, who becomes his agent (until 1958).

1950 Fall—teaches at the Royal College of Art, London, for a few weeks. Winter—sets off for several months in South Africa to see his mother; en route stops for a few days in Cairo.

1951 Completes first series of Popes.

1951–55 Moves several times within London.

1952 Spring—visits South Africa again.

1953 October–November—first solo exhibition held abroad, at Durlacher Brothers, New York. Paints *Two Figures*.

1954 Chosen as one of three artists (along with Ben Nicholson and Lucian Freud) to represent Great Britain at the *XXVII Venice Biennale*.

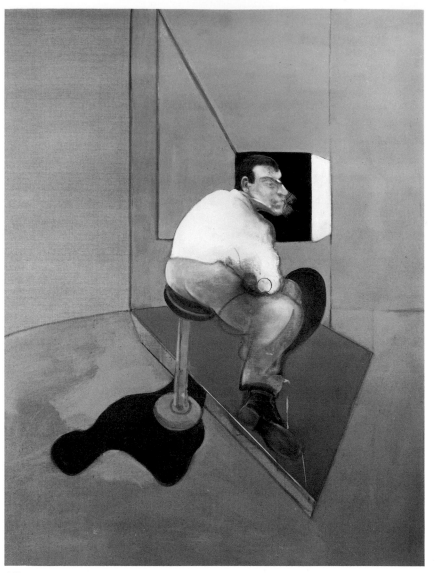

110

1955 January 20—retrospective exhibition opens at the Institute of Contemporary Arts, London.

1956 Visits his friend Peter Lacey in Tangier, where he rents an apartment. Returns often to Tangier during the next three years.

1957 February 12—first solo exhibition in Paris opens at the Galerie Rive Droite. March–April—a series of paintings after van Gogh is shown at the Hanover Gallery.

1958 First solo exhibitions held in Italy. Signs a contract with Marlborough Fine Art Ltd., London.

1959 September–December—solo exhibition held as part of the *V Bienal de São Paulo.* Spends a few months in St. Ives, Cornwall.

1960 March–April—first solo exhibition held at Marlborough Fine Art Ltd., London.

1961 Fall—moves to Kensington.

1962 May–July—the Tate Gallery, London, presents a major retrospective exhibition, which in modified form travels to a number of European cities. Bacon uses the large triptych format for the first time since 1944, in *Three Studies for a Crucifixion.*

1963–64 October–January—the Solomon R. Guggenheim Museum, New York shows his first American museum retrospective, which travels to the Art Institute of Chicago.

1964 Meets George Dyer, who appears in many of his paintings over the next decade and a half.

1967 Awarded the Painting Prize of the Pittsburgh International Series, Museum of Art, Carnegie Institute, Pittsburgh.

1968 Fall—visits New York for an exhibition of his recent paintings at Marlborough–Gerson Gallery.

1971 October 26—a major retrospective opens at the Grand Palais, Paris, which travels to the

Städtische Kunsthalle, Düsseldorf. George Dyer dies in Paris.

1972–74 Paints the "black" triptychs, influenced by Dyer's death.

1975 Spring—travels to New York for the opening of *Francis Bacon: Recent Paintings, 1968–1974* at the Metropolitan Museum of Art.

1977 Retrospective, organized by the National Museum of Modern Art, Tokyo, travels throughout Japan.

1983 Retrospective, organized by the Tate Gallery, travels to the Staatsgalerie, Stuttgart, and the Nationalgalerie, Berlin.

1985 Retrospective, organized by the Hirshhorn Museum, Washington, D.C., travels to the Los Angeles County Museum of Art and the Museum of Modern Art, New York.

1992 April 28—dies while vacationing in Madrid.

Exhibitions

1977

Francis Bacon: Oeuvres récentes, Galerie Claude Bernard, Paris, January 19–March 26.

Francis Bacon, Museo de Arte Moderna, Mexico City, October–December, and tour to Museo de Arte Contemporáneo, Caracas, Venezuela.

1978

Francis Bacon, Fundación Juan March, Madrid, February, and tour to Fundació Joan Miró, Barcelona.

1980

Francis Bacon: Schreiender Papst, 1951, Städtische Kunsthalle, Mannheim, West Germany, March 8–May 11.

Francis Bacon, Marlborough Gallery, New York, April 26–June 7.

1983

Francis Bacon: Paintings, 1945–1982, National Museum of Modern Art, Tokyo, June 30–August 14, and tour to Museum of Modern Art, Kyoto; Aichi Prefectural Art Gallery, Nagoya.

1984

Francis Bacon: Peintures récentes, Galerie Maeght-Lelong, Paris, January–February.

Francis Bacon: Recent Paintings, Marlborough Gallery, New York, May 5–June 5.

Francis Bacon, Thomas Gibson, London, June.

1985

Francis Bacon, Tate Gallery, London, May 22–August 18, and tour to Staatsgalerie, Stuttgart, West Germany; Nationalgalerie, Berlin.

1987

Francis Bacon: Paintings of the Eighties, Marlborough Gallery, New York, May 7–July 31.

Francis Bacon: Retrospektive, Galerie Beyeler, Basel, Switzerland, June 12–September 12.

1989

Francis Bacon, Hirshhorn Museum and Sculpture Garden, Smithsonian Institution, Washington, D.C., October 12, 1989–January 7, 1990, and tour to Los Angeles County Museum of Art; Museum of Modern Art, New York.

1993

Francis Bacon, Museo d'Arte Moderna della Città di Lugano, Lugano, Switzerland, March 7–May 30.

Figurabile: Francis Bacon, Museo Correr, Venice, June 13–October 10, as part of the 45th Venice Biennale.

1996

Francis Bacon, Musée National d'Art Moderne, Paris, June 27–October 14.

1998

Francis Bacon, Louisiana Museum of Modern Art, Humlebaek, Denmark, January 23–May 10.

Francis Bacon: The Human Body, Hayward Gallery, London, February 5–April 5.

Selected Group Exhibitions

1933

Exhibition of Recent Paintings by English and German Artists, Mayor Gallery, London, April.

Art Now, Mayor Gallery, London, October. Exhibition organized by Herbert Read in conjunction with his book of the same title.

1937

Young British Painters, Thomas Agnew and Sons, London, January.

1945

Recent Paintings by Francis Bacon, Frances Hodgkins, Henry Moore, Matthew Smith, Graham Sutherland, Lefevre Gallery, London, April.

1946

Recent Paintings by Ben Nicholson, Graham Sutherland, and Francis Bacon, . . . et al., Lefevre Gallery, London, February.

British Painters Past and Present, Lefevre Gallery, London, July–August.

French and English Paintings, Watercolours, Drawings, Original Prints, Redfern Gallery, London, July 11–September 28.

The Contemporary Art Society, Tate Gallery, London, September–October.

1950

London/Paris: New Trends in Painting and Sculpture, Institute of Contemporary Arts, London, March–April.

The Pittsburgh International Exhibition of Paintings, Carnegie Institute, Pittsburgh, October 19–December 21.

Fifteen Contemporary British Painters, City Art Gallery, Leeds, England, December–January 1951.

1951

British Painting, 1925–1950: First Anthology, Arts Council, London. Organized for the Festival of Britain.

1952

Recent Trends in Realist Painting, Institute of Contemporary Arts, London, July–August.

1953

Wonder and Horror of the Human Head: An Anthology, Institute of Contemporary Arts, London, March–April.

1954

XXVII Venice Biennale, Venice, June–October. Also included in 1978 and 1993.

Barbara Hepworth, Sculpture; Francis Bacon; Wm. Scott, Martha Jackson Gallery, New York, October 11–November 6.

1955

The New Decade: 22 European Painters and Sculptors, Museum of Modern Art, New York, May–August.

Francis Bacon, William Scott, and Graham Sutherland, Hanover Gallery, London, June 29–July 29.

1956

Britisk Kunst, 1900–1955, Kunstforeningen, Copenhagen, May–June, and tour.

Masters of British Painting, 1800–1950, Museum of Modern Art, New York, October 3–December 2, and tour.

1958

Three Masters of Modern British Painting, tour organized by Arts Council of Great Britain. With Matthew Smith and Victor Pasmore.

The 1958 Pittsburgh International Exhibition of Contemporary Painting and Sculpture, Carnegie Institute, Pittsburgh, December 5–February 8, 1959.

1959

Masterpieces of Art: W. R. Valentiner Memorial Exhibition, North Carolina Museum of Art, Raleigh, April 6–May 17.

Documenta II, Museum Fridericianum, Kassel, West Germany, July 11–October 11. Also included in 1977.

V Bienal de São Paulo, Museu de Arte Moderna, São Paulo, September–December.

New Images of Man, Museum of Modern Art, New York, September 30–November 29.

1960

Antagonismes, Musée des Arts Décoratifs, Paris, February.

XVIᵉ Salon de Mai, Musée d'Art Moderne de la Ville de Paris, May–June. Also included in 1961 and 1964.

Francis Bacon—Hyman Bloom, Art Galleries, University of California, Los Angeles, October 30–December 11.

1961

The James Thrall Soby Collection, M. Knoedler and Company, New York, February.

1962

Art since 1950, American and International, Seattle World's Fair, April 21–October 21.

L'Incontro di Torino, Palazzo della Promotrice al Valentino, Turin, Italy, September 20–October 20.

Hedendaagse Schilderkunst vit Londen, Stedelijk van Abbemuseum, Eindhoven, the Netherlands, October 20–December 10.

1963

Bacon—Sutherland, Galleria Il Centro, Naples, Italy, March–April.

Zeugnisse der Angst in der Modernen Kunst, Mathildenhöhe, Darmstadt, West Germany, June 28–September 1.

Idole und Dämonen, Museum des 20. Jahrhunderts, Vienna, July 5–September 1.

1964

Study for an Exhibition of Violence in Art, Institute of Contemporary Arts, London, Feb-

ruary–March.

Profile III: Englische Kunst der Gegenwart, Städtische Kunsthalle, Bochum, West Germany, April–June.

Painting and Sculpture of a Decade: 54–64, Tate Gallery, London, April 22–June 28.

British Malerei der Gegenwart, Kunstverein für die Rheinlande und Westfalen, Düsseldorf, May–July.

Figuratie, Defiguratie: De Menselijke Figuur sedert Picasso, Museum voor Schone Kunsten, Ghent, Belgium, July–October.

Engelsk Maleri i Dag, Louisiana Museum, Humlebaek, Denmark, September–December.

1965

The English Eye, Marlborough-Gerson Gallery, New York, November–December.

1966

Five Europeans, Fine Art Gallery, University of California, Irvine, May 17–June 12.

Fifty Years of Modern Art, 1916–1966, Cleveland Museum of Art, June 15–July 31.

1967

English Paintings, 1951–1967, Norwich Castle Museum, Norwich, England, May–July.

1968

Peintres européens d'aujourd'hui: European Painters Today, Musée des Arts Décoratifs, Paris, September 27–November 17, and tour.

1973

Cuatro Maestros contemporáneos: Giacometti, Dubuffet, de Kooning, Bacon, Museo de Bellas Artes, Caracas, Venezucla, April, and tour. Organized by the International Council of the Museum of Modern Art.

Henry Moore to Gilbert and George: Modern British Art from the Tate Gallery, Palais des Beaux-Arts, Brussels, September 28–November 17. Organized for "Europalia '73" by the Tate Gallery.

1974

La Ricerca dell'identità, Palazzo Reale, Milan, November 16–January 15, 1975.

Art du XXᵉ siècle: Fondation Peggy Guggenheim, Venice, Orangerie des Tuileries, Paris, November 30–March 3, 1975.

1975

Der Einzelne und die Masse: Kunstwerke des 19. und 20. Jahrhunderts: 29. Ruhrfestspiele, Städtische Kunsthalle, Recklinghausen, West Germany, May 22–July 10.

European Painting in the Seventies: New Work by Sixteen Artists, Los Angeles County Museum of Art, September 30–November 23, and tour.

English Portraits from Francis Bacon, The Philosopher, to Francis Bacon, The Painter, National Museum of Western Art, Tokyo, October 25–December 14. Organized in collaboration with the British Council.

British Painting, 1900–1960, Mappin Art Gallery, Sheffield, England, November–January 1976, and tour.

1976

Eros und Sexus in der Kunst des 20. Jahrhunderts, Galerie Rothe, Heidelberg, West Germany, July 3–September 5.

Modern Portraits: The Self and Others, Wildenstein, New York, October 20–November 28. Organized by the Department of Art History and Archaeology, Columbia University.

1977

Francis Bacon, Pablo Picasso, Galerie Theo, Madrid, March–April.

British Painting, 1952–1977, Royal Academy of Arts, London, September 24–November 20.

Artists View the Law in the 20th Century, David and Alfred Smart Gallery, University of Chicago, October 5–November 27.

1978

Art in Western Europe: The Postwar Years, 1945–1955, Des Moines Art Center, Des Moines, Iowa, September 19–October 29.

Clive Barker: 12 Studies of Francis Bacon; Francis Bacon: 3 Studies of Clive Barker, Felicity Samuel Gallery, London, October 16–December 1.

1979

Thirties: British Art and Design before the War, Hayward Gallery, London, October 25–January 13, 1980. Organized by the Arts Council of Great Britain in collaboration with the Victoria and Albert Museum.

This Knot of Life: Paintings and Drawings by British Artists, L.A. Louver Gallery, Los Angeles, November 27–December 22.

1980

Corps: Tours Multiple, Tours, France, February 8–March 23. Organized by Tours Arts Vivant and held at various sites in Tours.

1981

Spiegelbilder, Kunstverein, Hannover, West Germany, May 9–June 30.

Westkunst: Zeitgenossische Kunst seit 1939, Museen der Stadt Köln, Cologne, West Germany, May 30–August 16.

8 Figurative Painters, Yale Center for British Art, New Haven, Connecticut, October 14–January 3, 1982, and tour.

1983

Modern Nude Paintings, 1880–1980, National Museum of Art, Osaka, Japan, October 7–December 4.

Three Exhibitions about Painting, Graves Art Gallery, Sheffield, England, December 28–January 29, 1984, and tour. Organized by the Arts Council of Great Britain.

1984

Ten Years of Collecting at the MCA, Museum of Contemporary Art, Chicago, April 14–June 10.

The Hard-Won Image: Traditional Method and Subject in Recent British Art, Tate Gallery, London, July 4–September 9.

Creation: Modern Art and Nature, Scottish National Gallery of Modern Art, Edinburgh, August 15–October 14.

Donation Louise et Michel Leiris: Collection Kahnweiler-Leiris, Musée National d'Art Moderne, Paris, November 22–January 28, 1985.

La Grande Parade: Hoogtepunten van de Schilderkunst na 1940: Highlights in Painting after 1940, Stedelijk Museum, Amsterdam, December 15–April 15, 1985.

1985

L'Autoportrait à l'âge de la photographie: Peintres et photographes en dialogue avec leur propre image, Musée Cantonal des Beaux-Arts, Lausanne, Switzerland, January 18–March 24, and tour.

Public Collections

Aberdeen, Scotland, Aberdeen Art Gallery
Adelaide, Australia, Art Gallery of South Australia
Amsterdam, The Netherlands, Stedelijk Museum
Belfast, Northern Ireland, Ulster Museum
Berlin, West Germany, Nationalgalerie
Bilbao, Spain, Museo de Bellas Artes
Birmingham, England, City Art Gallery
Bochum, West Germany, Museum Bochum
Brussels, Belgium, Musées Royaux des Beaux-Arts de Belgique
Buffalo, New York, Albright-Knox Art Gallery
Canberra, Australia, National Gallery of Australia
Caracas, Venezuela, Museo de Arte Contemporáneo
Cardiff, Wales, National Museum of Wales
Chicago, Illinois, Art Institute of Chicago
Chicago, Illinois, Museum of Contemporary Art
Cleveland, Ohio, Cleveland Museum of Art
Cologne, West Germany, Museum Ludwig
Dallas, Texas, Dallas Museum of Art
Des Moines, Iowa, Des Moines Art Center
Detroit, Michigan, Detroit Institute of Arts
Düsseldorf, West Germany, Kunstsammlung Nordrhein-Westfalen
Eindhoven, The Netherlands, Stedelijk van Abbemuseum
Frankfurt am Main, West Germany, Städelsches Kunstinstitut
Ghent, Belgium, Museum voor Hedendaagse Kunst
Göteborg, Sweden, Göteborgs Konstmuseum
The Hague, The Netherlands, Gemeentemuseum

Hamburg, West Germany, Hamburger Kunsthalle
Hannover, West Germany, Sprengel-Museum
Helsinki, Finland, Atheneumin Taidemuseo
Honolulu, Hawaii, Honolulu Academy of Arts
Huddersfield, England, Huddersfield Art Gallery
Humlebaek, Denmark, Louisiana Museum
Ito, Japan, Ikeda Museum of Twentieth-Century Art
Jerusalem, Israel, Israel Museum
Johannesburg, Republic of South Africa, Johannesburg Art Gallery
Leeds, England, Temple Newsam House
Leicester, England, Leicester Museum and Art Gallery
Liège, Belgium, Musée des Beaux-Arts
London, England, Arts Council of Great Britain
London, England, Peter Stuyvesant Foundation
London, England, Royal College of Art
London, England, Tate Gallery
Madrid, Spain, Museo Español de Arte Contemporáneo
Manchester, England, City Art Gallery
Manchester, England, Whitworth Art Gallery
Mannheim, West Germany, Städtische Kunsthalle
Marseilles, France, Musée Cantini
Melbourne, Australia, National Gallery of Victoria
Mexico City, Mexico, Museo Rufino Tamayo
Milan, Italy, Pinacoteca di Brera
Minneapolis, Minnesota, Minneapolis Institute of Arts
Munich, West Germany, Staatsgalerie Moderner Kunst

Newcastle upon Tyne, England, Hatton Gallery, University of Newcastle upon Tyne
New Haven, Connecticut, Yale University Art Gallery
New York, New York, Museum of Modern Art
New York, New York, Solomon R. Guggenheim Museum
Norwich, England, Sainsbury Centre for Visual Art, University of East Anglia
Omaha, Nebraska, Joslyn Art Museum
Ottawa, Canada, National Gallery of Canada
Oxford, England, Pembroke College
Paris, France, Musée National d'Art Moderne, Centre National d'Art et de Culture Georges Pompidou
Poughkeepsie, New York, Vassar College Art Gallery
Rotterdam, The Netherlands, Museum Boymans-van Beuningen
Stockholm, Sweden, Moderna Museet
Stuttgart, West Germany, Staatsgalerie Stuttgart
Sydney, Australia, Art Gallery of New South Wales
Tokyo, Japan, National Museum of Modern Art
Toyama, Japan, Museum of Modern Art
Turin, Italy, Galleria d'Arte Moderna
Vatican City, Collezione d'Arte Religiosa Moderna, Musei Vaticani
Washington, D.C., Hirshhorn Museum and Sculpture Garden, Smithsonian Institution
Washington, D.C., Phillips Collection
Wuppertal, West Germany, Von der Heydt-Museum
Zurich, Switzerland, Kunsthaus Zürich

Selected Bibliography

Interviews and Statements

Bacon, Francis. "Matthew Smith—A Painter's Tribute." In *Matthew Smith: Paintings from 1909 to 1952*. London: Tate Gallery, 1953.

————. *Francis Bacon in Conversation with Michel Archimbaud*. London: Phaidon, 1993.

Gilder, Joshua. "I Think about Death Every Day." *Flash Art* 112 (May 1983): 17–21. Interview. Originally published in *Saturday Review*, September 1981, pp. 36–39.

Gross, Miriam. "Bringing Home Bacon." *Observer*, November 30, 1980, pp. 29–31. Interview.

Peppiatt, Michael. "From a Conversation with Francis Bacon." *Cambridge Opinion* 37 (January 1964): 18–19.

Ritchie, Andrew Carnduff, ed. *The New Decade: 22 European Painters and Sculptors*. New York: Museum of Modern Art, 1955. Includes statements.

Spender, Stephen. "Der Tradition eine neue Wendung Geben: Ein Gesprach mit dem Maler Francis Bacon." *Die Weltwoche* (Zurich), October 19, 1962, p. 27. Interview.

Sylvester, David. "The Art of the Impossible." *Sunday Times Colour Magazine* (London), July 14, 1963, pp. 13–18. Text of a conversation with Francis Bacon, broadcast on the BBC, October 21, 1962.

————. *The Brutality of Fact: Interviews with Francis Bacon*. London: Thames and Hudson, 1987.

Monographs and Solo-Exhibition Catalogs

Ades, Dawn, and Forge, Andrew. *Francis Bacon*. London: Tate Gallery, 1985. Includes a note on technique by Andrew Durham and an extensive bibliography compiled by Krzysztof Cieszkowski.

Alley, Ronald. Introduction to *Francis Bacon*. Hamburg: Kunstverein, 1965.

Alley, Ronald, and Rothenstein, John. *Francis Bacon*. London: Tate Gallery, 1962.

————. *Francis Bacon*. London: Thames and Hudson, 1964. Catalogue raisonné and documentation.

Alloway, Lawrence. Introduction to *Francis Bacon*. New York: Solomon R. Guggenheim Museum, 1963.

Alphen, Ernst van. *Francis Bacon and the Loss of Self: Essays in Art and Culture*. Cambridge: Harvard University Press, 1994.

Bacon. Paris: Editions George Fall, 1978. No. 68 of *Opus International*. Special issue devoted to Bacon.

Borel, France. *Bacon: Portraits and Self-Portraits*. Introduction by Milan Kundera. London and New York: Thames and Hudson, 1996.

Calvocoressi, Richard, and Philip Long, eds. *From London*. London: British Council; Edinburgh: Scottish National Gallery of Modern Art, 1995.

Carluccio, Luigi. Introduction to *Francis Bacon*. Milan: Galleria d'Arte Galatea, 1962.

————. "Bacon, Il Potere el la gloria." In *Francis Bacon*. Turin, Italy: Galleria Civica d'Arte Moderna, 1962.

————. Introduction to *Francis Bacon*. Rome: Galleria Il Fante di Spade, 1965.

————. Introduction to *Francis Bacon: Mostra di undici dipinti*. Milan: Toninelli Arte Moderna, 1966.

Chiappini, Rudy, ed. *Francis Bacon*. Milan: Electa, 1993.

Clarac-Serou, Max. Introduction to *Paintings by Francis Bacon*. London: Institute of Contemporary Arts, 1955.

Correa, Antonio Bonet. Introduction to *Francis Bacon*. Barcelona: Fundació Joan Miró, 1978.

Dagen, Philippe. *Francis Bacon*. Paris: Cercle d'Art, 1996.

Davies, Hugh M. *Francis Bacon: The Early and Middle Years, 1928–1958*. New York: Garland, 1978. Reprint of the author's Ph.D. dissertation, Princeton University, 1975. Includes extensive bibliography.

Deleuze, Gilles. *Francis Bacon: Logique de la sensation*. 2 volumes. Paris: Editions de la Différence, 1981.

Duckers, Alexander. *Francis Bacon: Painting 1946*. Stuttgart, West Germany: Reclam, 1971. Monograph on the painting in the Museum of Modern Art, New York.

Dupin, Jacques. Preface to *Francis Bacon: Peintures récentes*. Paris: Galerie Maeght-Lelong, 1984. Includes an interview by David Sylvester.

Francis Bacon. London: Marlborough New London Gallery, 1963. Includes an interview by David Sylvester.

Francis Bacon. Paris: Centre Georges Pompidou, 1996.

Geldzahler, Henry. Introduction to *Francis Bacon: Recent Paintings, 1968–1974*. New York: Metropolitan Museum of Art, 1975.

Gowing, Lawrence. "The Irrefutable Image." In *Francis Bacon: Recent Paintings*. New York: Marlborough-Gerson Gallery, 1968.

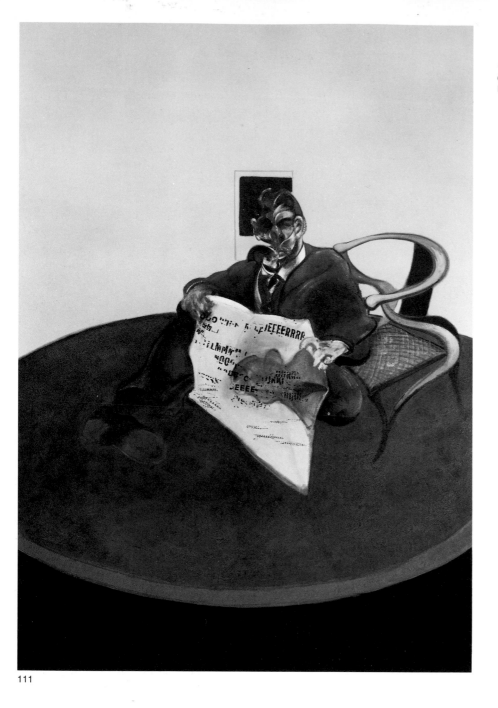

111

111. *Study for Portrait*, 1970
Oil on canvas, 78 x 58 in.
Private collection, France

———. Introduction to *Francis Bacon: Paintings, 1945–1982*. Tokyo: National Museum of Modern Art, 1983.

Gowing, Lawrence, and Sam Hunter. *Francis Bacon*. Washington, D.C.: Hirshhorn Museum and Sculpture Garden, Smithsonian Institution; New York: Thames and Hudson, 1989.

Heusinger von Waldegg, Joachim. *Francis Bacon: Schreiender Papst, 1951*. Mannheim, West Germany: Städtische Kunsthalle, 1980.

Lascault, Gilbert. *Francis Bacon*. Paris: Centre National de Documentation Pédagogique, 1978. In the series "Actualité des Arts Plastiques," 39. Includes 24 slides.

Leiris, Michel. "What Francis Bacon's Paintings Say to Me." In *Francis Bacon: Recent Paintings*. London: Marlborough Fine Art Ltd., 1967. In French and English; includes interview by David Sylvester, May 1966.

———. "Francis Bacon Aujourd'hui." In *Francis Bacon*. Paris: Grand Palais, 1971. Includes extensive bibliography.

———. *Francis Bacon ou la vérité criante*. Paris: Editions Fata Morgana, 1974.

———. *Francis Bacon: Full Face and in Profile*. New York: Rizzoli, 1983. Includes original French text.

Lessore, Helen. Introduction to *Francis Bacon*. Nottingham, England: Nottingham University, 1961.

Linfert, Carl. *Francis Bacon*. Seigen, West Germany: Rubenspreis, 1967.

Melville, Robert. Introduction to *Francis Bacon: Paintings, 1959–60*. London: Marlborough Fine Art Ltd., 1960. Originally printed in the catalog for the V Bienal, São Paulo, 1959.

Oliva, Achille Bonito, ed. *Figurabile*. Milan: Electa, 1993.

Penrose, Roland. Introduction to *Francis Bacon*. Paris: Galerie Rive Droite, 1957.

Peppiatt, Michael. *Francis Bacon: Anatomy of an Enigma*. New York: Farrar Straus and Giroux, 1997.

Rothenstein, John. *Francis Bacon*. London: Purnell & Sons, 1967. The Masters series, no. 71. Originally published in 1963.

Russell, John. *Francis Bacon*. World of Art series. London: Thames and Hudson, 1993.

Schmied, Wieland. *Francis Bacon: Commitment and Conflict*. Translated by John Ormrod. Munich and New York: Prestel, 1996.

Spender, Stephen. Introduction to *Francis Bacon*. Mannheim, West Germany: Städtische Kunsthalle, 1962. Reprinted in *Francis Bacon*, Zurich: Kunsthaus Zurich, 1962.

Sylvester, David. Introduction to *Francis Bacon*. Milan: Galleria dell'Ariete, 1958. Reprinted from the catalog to the *XXVII Venice Biennale*, 1954.

———. "Some Notes on the Paintings of Francis Bacon." In *Francis Bacon*. Paris: Galerie Rive Droite, 1957.

Trucchi, Lorenza. *Francis Bacon*. New York: Harry N. Abrams; London: Thames and Hudson, 1976. Originally published in Italian by Milan: Fratelli Fabbri Editori, 1975.

Periodicals, Books, and Group-Exhibition Catalogs

Alley, Ronald. "Francis Bacon." *Cimaise* 10 (January–February 1963): 12–25.

Alloway, Lawrence. "Francis Bacon: A Great, Shocking, Eccentric Painter." *Vogue*, November 1963, pp. 136–39.

———. "Bacon, Le Convulsif: Ou, L'Angoisse sied aux héros." *XXᵉ Siècle* 3 (May 1964): 27–34.

Battcock, Gregory. "Francis Bacon." *Arts Magazine* 43 (November 1968): 46–47. Review of exhibition at Marlborough-Gerson Gallery.

Berger, John. "Francis Bacon and Walt Disney." In *About Looking*. New York: Pantheon, 1980. Originally published in *New Society*, 1972.

Calhoun, Alice Ann. "Suspended Projections: Religious Roles and Adaptable Myths in John Hawkes's Novels, Francis Bacon's Paintings, and Ingmar Bergman's Films." Ph.D. dissertation, University of South Carolina, 1979. Available through Dissertation Abstracts International (order no. 80 13944).

Chavarri, R. "Bacon: Fundamentos de la autodestruccion." *Cuadernos Hispanoamericanos* (Spain) 340 (1978): 165–70.

Clark, Kenneth. "The New Romanticism in British Painting." *Artnews* 45 (February 1947): 24–29, 56–58. Review of *Contemporary British Painters* at Albright Art Gallery.

Davies, Hugh M. "Bacon's 'Black' Triptychs." *Art in America* 63 (March–April 1975): 62–68.

Deleuze, Gilles. "Francis Bacon: The Logic of Sensation." *Flash Art* 112 (May 1983): 8–16.

———. "Books." *Artforum* 22 (January 1984): 68–69.

Forge, Andrew. "Bacon: The Paint of Screams." *Artnews* 62 (October 1963): 38–41, 55–56.

"Francis Bacon: This Month's Choice of a Unique Painter." *Mizue* (Tokyo) 727 (September 1965): 20–31.

Gorsen, Peter. "Die Revision des Portrats durch Francis Bacon." *Das Kunstwerk* 17 (August–September 1963): 4–33.

Griffin, Howard. "Francis Bacon." *Studio* 161 (May 1961): 164–69.

Harriman, Virginia. "A Disquieting Nude by Francis Bacon." *Bulletin of the Detroit Institute of Arts* 36 (1956–57): 16–18.

Harrison, Jane. "Dissent on Francis Bacon." *Arts Magazine* 38 (December 1963): 18–23.

Henning, Edward B. "A Painting by Francis Bacon." *Bulletin of the Cleveland Museum of Art* 70 (November 1983): 354–59.

Henry, Gerrit. "Bacon Is Nowhere Near the Gentleman That Some of Our Rebels Have Made Him Out to Be." *Artnews* 74 (May 1975): 31–32. Review of exhibition at Metropolitan Museum of Art.

Hoctin, Luce. "Francis Bacon et la hantise de l'homme." *XXᵉ Siècle* 11 (December 1958): 53–55.

Hughes, Robert. "Singing within the Bloody Wood." *Time*, July 1, 1985, pp. 54–55. Review of exhibition at Tate Gallery.

Hunter, Sam. "Francis Bacon: The Anatomy of Horror." *Magazine of Art* (Washington, D.C.) 95 (January 1952): 11–15.

———. "Francis Bacon: An Acute Sense of Impasse." *Art Digest* 28 (October 15, 1953): 16. Review of exhibition at Durlacher Brothers.

Kenedy, R. C. "Francis Bacon." *Art International* 10 (December 1966): 24, 28–29.

Kuspit, Donald. "Francis Bacon: The Authority of Flesh." *Artforum* 13 (summer 1975): 50–59.

Laessoe, Rolf. "Francis Bacon and T. S. Eliot." *Hafnia: Copenhagen Papers in the History of Art* 9 (1983): 113–30.

Lascault, Gilbert. "Francis Bacon: Les Chefs-d'oeuvre reconnus." *XXᵉ Siècle* 45 (December 1975): 20–27.

Leiris, Michel. "Le Grand Jeu de Francis Bacon." *XXᵉ Siècle* 49 (December 1977): 16–20.

———. *Bacon, Picasso, Masson*. Frankfurt am Main, West Germany: Qumran, 1982.

Lessore, Helen. "A Note on the Development of Francis Bacon's Painting." *X* (London) 2 (March 1961): 23–26.

———. "Francis Bacon." *Goya* 127 (July 1975): 27–33.

Melville, Robert. "Francis Bacon." *Horizon* (London) 20 (December 1949–January 1950): 419–23.

———. "Der Maler Francis Bacon." *Werk* (Winterthur) 48 (January 1961): 30–32.

———. "Francis Bacon." *Studio International* 168 (July 1964): 10–15.

Micha, René. "Le Francis Bacon de Gilles Deleuze." *Art International* 25 (May–June 1982): 109–16.

Murray, Philippe. "Francis Bacon: Les Cadavres dans le triptyque." *Art Press International* (Paris) 59 (May 1982): 18–20.

"The 1930 Look in British Decoration." *Studio* 60 (August 1930): 140–41.

O'Doherty, Brian. "On the Strange Case of Francis Bacon." *Art Journal* 24 (spring 1965): 288–90. Review of exhibition at Guggenheim Museum, originally published in the *New York Times*, October 20, 1963, p. 17.

Parinaud, Marie-Hélène. "Bacon: La Présence du vide." *Galerie-Jardin des Arts* 166 (February 1977): 55. Review of exhibition at Galerie Claude Bernard.

Peppiatt, Michael. "Francis Bacon and the Waste Land." *Connaissance des Arts* (U.S. edition) 16 (May 1981): 40–49. Also published in French edition as "Les Rêves décomposés de Francis Bacon," 351 (May 1981): 48–57.

———. "Francis Bacon: The Studio as Symbol." *Connoisseur* 214 (September 1984): 84–93.

Perreault, John. "Bacon Fat." *Soho Weekly*

News, March 27, 1975, pp. 15, 33. Review of exhibition at Metropolitan Museum of Art.

Pincus-Witten, Robert. "Francis Bacon." *Artforum* 7 (January 1969): 57. Review of exhibition at Marlborough Gallery. Reprinted in *Looking Critically: 21 Years of Artforum Magazine,* Ann Arbor: UMI Research Press, 1984.

Read, Herbert. *Art Now.* London: Faber and Faber, 1933.

———. *Contemporary British Art.* Harmondsworth, England: Penguin Books, 1951.

Ritchie, Andrew Carnduff. *Masters of British Painting, 1800–1950.* New York: Museum of Modern Art, 1956.

Roskill, Mark. "Francis Bacon as a Mannerist." *Art International* 7 (September 25, 1963): 44–48. Review of exhibition at Guggenheim Museum.

Russell, John. "Peer of the Macabre: Francis Bacon." *Art in America* 52 (October 1963): 100–103.

———. "Francis Bacon at Sixty." *Art in America* 58 (January 1970): 106–11.

———. "Time Vindicates Francis Bacon's Searing Vision." *New York Times,* June 9, 1985, p. 31. Review of exhibition at Tate Gallery.

Selz, Peter. *New Images of Man.* New York: Museum of Modern Art, 1959.

Soby, James Thrall. *Contemporary Painters.* New York: Museum of Modern Art, 1948.

Spender, Stephen. "English Artists vs. English Painting." *Artnews* 52 (November 1953): 14–17, 46–49.

———. "Francis Bacon." *Quadrum* (Brussels) 11 (1961): 47–58.

Sperlich, Hans-Gunther. "Raum-Ansichten," in *Zeugnisse der Angst in der Modernen Kunst.* Darmstadt, West Germany: Mathildenhohe, 1963.

"Survivors." *Time,* November 21, 1949, p. 44.

Sylvester, David. "Dark Sunlight." *Sunday Times Colour Magazine* (London), June 2, 1963, pp. 3–14.

———. "Enter Bacon, with the Bacon Scream." *New York Times Magazine,* October 19, 1963, pp. 24–25, 57–64. Review of exhibition at Guggenheim Museum.

Taillandier, Yvon. "Francis Bacon ou l'espace du 'Naissant.'" *XXᵉ Siècle* 38 (June 1972): 56–66. Review of exhibition at Grand Palais.

Turner, Evan H. "Destruction: A Factor in Contemporary Art." *Canadian Art* 23 (January 1966): 38–43.

Wolfram, Eddie. "Bringing Home the Bacon." *Art and Artists* 6 (November 1971): 42–45.

Films

Après Hiroshima . . . Francis Bacon? 1984. Interview with Pierre Daix for the French television program *Désir des arts.* Made in connection with the exhibition at Galerie Maeght-Lelong, Paris, 1984.

The Brutality of Fact. 1984. Interview with David Sylvester. Directed by Michael Blackwood. Produced by Alan Yentob. Made by BBC Television, London, for *Arena.*

Francis Bacon. 1969. Produced by BBC Television, London. Released in the United States by Time-Life Films. 31 minutes.

Francis Bacon. 1971. Directed by J. M. Berzosa for ORTF, Paris. Film of an interview with Maurice Chapuis made in connection with the retrospective exhibition at the Grand Palais, Paris.

Francis Bacon. 1985. Interview with Melvyn Bragg for the *South Bank Show,* London Weekend Television.

Francis Bacon: Fragments of a Portrait. 1966. Interview with David Sylvester. Directed by Michael Gill for BBC Television, London.

Francis Bacon: Grand Palais. 1971. Directed by Gavin Millar. Produced by Colin Nears for BBC Television, London. Made in connection with the retrospective exhibition at the Grand Palais, Paris.

Francis Bacon: Paintings, 1944–1962. 1963. Directed by Dudley Shaw Ashton. Written by David Thompson. Produced by Samaritan Films for the Arts Council of Great Britain and Marlborough Fine Art Ltd., London. Distributed in the United States by the American Federation of Arts, Washington, D.C. 11 minutes.

Portrait of Francis Bacon. 1974. Directed by Thomas Ayck for NDR Television, Hamburg.

Regards entendus Francis Bacon. 1983. Written by Michel Leiris. Produced by Constantin Jelenski, Institut National de l'Audiovisuel, Bry-sur-Marne, for French television.

Sides of Bacon. 1975. Interview with David Sylvester. Produced by Aquarius for London Weekend Television.

Index

127

Photography Credits

All photographic materials were obtained directly from the sources indicated in the captions or from Marlborough International Fine Art, London, with the following exceptions: plate 18, Arte Fotografica; plate 34, Roy Porello; and plate 52, Juhani Riekkola.